HAUNTED
LONGMONT

HAUNTED LONGMONT

RICHARD ESTEP

Haunted America

Published by Haunted America
A Division of The History Press
Charleston, SC 29403
www.historypress.net

Back cover, lower left: Courtesy of the Longmont Museum.

First published 2015

Manufactured in the United States

ISBN 978.1.46711.796.8

Library of Congress Control Number: 2015939785

Notice: The information in this book is true and complete to the best of our knowledge. It is offered without guarantee on the part of the author or The History Press. The author and The History Press disclaim all liability in connection with the use of this book.

For the guardian angels of Longmont…past, present and future. Firefighters, law enforcement officers, EMTs, paramedics and the dispatchers who send them into harm's way…no matter whose patch they wear.

The presence of those seeking the truth is infinitely to be preferred to the presence of those who think they've found it.
—*Sir Terry Pratchett,* Monstrous Regiment

CONTENTS

CONTENTS

ACKNOWLEDGEMENTS

My undying thanks:
　　　To Laura and Greta, who both know why.

To Artie, for giving me the chance.

To my brothers and sisters at Boulder Rural Fire Rescue and Rural/Metro-Pridemark Paramedics, who consistently put it all on the line to protect the public. I love you all more than you will ever know.!

To the men and women of the Boulder County Paranormal Research Society, the best bunch of ghost hunters I could ever wish to work for. Thank you for all that you do.

To Rhonda Conrad and Michelle Gomez, for opening doors.

To Gail Jones, Eric Jones and Diane Lane, along with the good folks at Spirit Connection Investigations.

To the gang at the Other Side Investigations and Stephen Weidner's AAPI crew, for sharing lots of nights in dark places with us.

To Peter Schow, for creating such a valuable historical resource.

To each and every citizen of Longmont who kindly agreed to be interviewed for this book.

To Heather Berzina and Jenna Steege, for talking openly about their encounter with the paranormal.

And lastly, to my friend and brother, firefighter-paramedic Troy Bohm, for insisting that there is no such thing as ghosts…despite all the evidence.

The Pridemark spirit will never die!

INTRODUCTION

It has been over one hundred years since the level of popular interest in the subject of ghosts and the paranormal has been as high as it is today. The American public has long been fascinated with stories of haunted houses, haunted objects and—yes—haunted people. With *Ghost Hunters* and *Ghost Adventures* garnering massive ratings on television and movies such as *The Conjuring* ruling at the box office, it appears that we are surrounded by the spirits of the unquiet dead, seemingly lurking out of sight within every dark corner.

Sharing in this passion for the paranormal, I began to investigate claims of ghosts and haunted houses back in the mid-1990s, when the only public awareness of such things came via the publishing world. I am also a transplanted Englishman, who relocated to the United States in 1999. Longmont turned out to be a friendly, welcoming sort of place, and I have made my home there and put down roots.

After a brief stint with a local paranormal organization, I split away and decided to found my own. Along with my wife, Laura, I co-founded the Boulder County Paranormal Research Society in 2006, with a view toward tracking down the ghosts of Colorado's Front Range. Particular emphasis was spent on my adoptive hometown, whose historic buildings and back streets have provided an endless source of fascination and discovery.

For every storied historic building and public facility that my team and I have investigated, such as the beautiful Dickens Opera House and Tavern, there have also been calls for help from everyday folks living in everyday

houses, some of whom are scared half out of their wits by paranormal activity taking place right in their own homes.

Collected within the pages of this volume are stories of the ghostly and the macabre. You will encounter the spirits of those who died peacefully and may have returned to visit places that they loved during their mortal lifetimes. You will also find those who met tragic—often violent—endings and whose spirits tend to manifest themselves in equally disturbing ways.

Researching the paranormal can be a murky field of endeavor at best. Particularly when one tries to look backward in history over more than a few short decades, sources of information can be at variance with one another or difficult to pin down exactly. Because ghost stories are so often found in the realm of urban legends and myths, passed on from person to person in the age-old tradition of oral storytelling, facts become blurred and distorted in the same way as they do during a game of "Telephone." I have gone to great pains to research the cases that are recounted in this book, in as thorough a manner as was possible, but inevitably, one or two small factual errors may have crept in. These are almost certainly attributable to me and not to any of the people who generously gave up their time to be interviewed.

When writing this book, my intent was to cover a broad spectrum of cases. Some of them are grounded a little more firmly in cold, hard fact than are others. This is partly because, in my role as director of the Boulder County Paranormal Research Society, I have actually spent many hours overnighting in some of the buildings mentioned, working diligently with my colleagues to investigate the claims of ghostly occurrences. But I have not had the opportunity to do so in every instance. For example, although I have been fortunate enough to personally investigate the haunting of the Dickens Opera House and Tavern, its counterpart (the Dickens Manor Apartments) is now a series of private dwellings and is therefore not open to conducting an overnight ghost hunt. I have interviewed witnesses personally where possible.

And so, this book runs the gamut between fact and fable but tries to stick to the established facts where they were available. Many of the places about which you are soon to read happen to be open to the public, and I strongly encourage you to go and check them out for yourself.

Lastly, my sincere thanks are due to you, the reader. In parting with your hard-earned cash for this book, you will hopefully be happy to hear that 10 percent of the royalties for this book are being donated by the author to the Longmont Humane Society. Thank you for helping the animals of Longmont to stay safe and well.

I hope that you are sitting comfortably, with a glass of your favorite beverage close at hand. Close the curtains and turn on the lights to help keep out the darkness. I would like to thank you for choosing to join me on this guided tour through the haunted history of one of Colorado's most colorful cities.

It's time to go and introduce ourselves to the ghosts of Longmont.

Chapter 1

STAN, STAN, THE SANITATION MAN

THE OLD CITY SANITATION BUILDING, 103 MAIN STREET—CURRENTLY CHEESE IMPORTERS

Sitting on the northwest corner of the intersection between First Avenue and Main Street, directly facing what was once the city's turkey processing plant, is an unassuming building that is currently home to a company named Cheese Importers. Hundreds of Longmont residents pass by along Main Street every day, with many of them giving little or no thought whatsoever to the colorful backstory of this fine old brick structure.

Cheese Importers is a homegrown Colorado family business, ever since the day in 1976 when Lyman White and his wife, Linda, both veterans of the natural food industry, decided that they could provide better cheese to the public than what was currently available, the vast majority of which was artificially processed.

The company took off, outgrowing its premises and requiring a little more operating space as the demand for its product grew. It took quite a while to find the perfect location, but time and circumstance came together, and the perfect place soon became available in the form of 103 Main Street.

After some negotiation with the powers that be, the Whites were fortunate enough to obtain a long-term lease on what was formerly the old City of Longmont museum storage facility.

Cheese Importers at 103 Main Street was formerly a city facility and is said to be haunted by the ghost of a former employee. *Author's collection.*

Despite Lyman's tragic death in a motorcycle accident, Cheese Importers has remained a family business, with the managerial baton being passed to the custodianship of the White children, Samm and Clara Natasha, with Linda still retaining an active role in guiding this very successful commercial enterprise.

Built in 1931, 103 Main Street was originally a diesel-fueled power plant that used five massive generators to supply the city of Longmont with electricity up until the late 1960s. The city sanitation department took it over in 1979, which is when the stories of ghostly activity began to appear.

In an article titled "Familiar Haunts," journalist Matt Reed of the *Longmont Times-Call* newspaper reports that Sanitation Department workers who were alone in the building at night would often hear their names being called out in an unidentified man's voice—despite the doors being tightly locked and a motion sensor–equipped alarm system being in operation at the time.

The metal doors of lockers used to store personal effects and clothing were known to slam open and shut repeatedly, despite there being nobody within touching distance. The clanking of chain links moving is another sound that employees grew familiar with, and most believed the sound came from a chain-link hoist that was suspended from the ceiling. The article quotes Sanitation Director Tim Lucas as saying, "It's distinctly coming from inside the building. That doggone hoist is a regular occurrence."

Intrigued by the ghostly tales, I visited the building at 103 Main Street back in 2008 when I had just recently founded the Boulder County

Paranormal Research Society and was actively seeking out potential cases to investigate. At that time, it was still home to the overflow storage of the Longmont Museum. "That doggone hoist" to which Tim Lucas refers is a metal chain and pulley hoist, which is mounted high up on the bay wall inside. The museum staff confirmed to me that the chains are often heard to clank and squeal, as if being pulled by unseen hands. I inspected the pulley-and-chain setup, and the thing that struck me at first glance was that it would be extremely difficult to reach without setting up a ladder first.

"There's a difference between the normal settling sounds a building makes and the strange noises you hear in here," says Tim Lucas at the conclusion of Matt Reed's article. "I don't think you'll catch any one of my crew coming down here at night."

That sounded like just the sort of thing I was looking for. To my surprise, city officials gave me permission to conduct an overnight investigation (with the caveat that I didn't write about it so long as the building was a museum storage facility), and I jumped at the opportunity. We were blessed with an overabundance of personnel: a total of fourteen investigators and three staff members from the City of Longmont.

My first question to the staff members who were present at the time was: "Who do you think the ghost is?" They told me that former city sanitation workers still dropped by the place from time to time, and almost every one spoke of the resident ghost with something close to affection. The prevailing theory seemed to be that he was the ghost of a former sanitation worker who loved his place of employment enough to want to revisit it after his death, a theory that is quite plausible. No records could be found of a death occurring on the property itself, so the city workers had gone ahead and given their spook a fond nickname. They called him "Stanley."

Investigating the property turned out to be quite the challenge. It was crammed to the roof with some of the most incredible artifacts. One personal favorite of mine was an old NORAD missile command station and screen, the type you see in thriller movies where a sweating air force tech is tracking inbound nuclear warheads. Alongside this particular piece of 1950s technology were antique coal scuttles and fireplaces, the new and the old stored together with no discernible rhyme or reason.

Because of the almost priceless nature of some of the artifacts stored there, the museum facility must maintain a constant air temperature at all times. This is achieved by running the air conditioning unit constantly, at all hours of the day or night—which is great for temperature regulation but lousy for paranormal investigators who perk up their ears every time

Some contents of the old city museum storage facility, which used to reside at 103 Main Street. The building is now leased to a cheese retail company. *Miranda Armstrong Metzger.*

somebody feels a cold draft. Cold drafts were the norm in this place, so any cold spots had to be written off as not constituting any kind of evidence.

I'd made the rather unusual move of trying out two people who claimed to have psychic abilities. I was curious about whether they'd uncover any useful information about the identity of "Stanley" or whatever his real name was. The first, a man named David, said that he was drawn to an antique television because "some kind of violent accident is associated with this area of the building." He then clarified this statement by saying that this was an old event, not currently affecting activity in the building and completely unrelated to any entities that might be haunting the place.

Advancing to the second floor, David moved straight away to a room that was filled with old hats. "There's an active spirit entity of some kind in this room," he declared. "This is a very active energy form indeed."

Intrigued (but having no hard evidence to back up David's claims), I moved on to our second sensitive, a lady by the name of Robbin. After walking around for a while and getting comfortable with the layout of the place, Robbin declared that she had felt nothing at all of note on the ground floor. As I accompanied her up to the second floor, Robbin suddenly pointed and exclaimed that she had seen a shape of some kind flitting across the second-floor balcony.

Interestingly enough, she was also drawn to the room that stored the collection of hats, just as David had been. However, rather than sensing an active presence within that room, she reported a more generalized "oppressive feeling," particularly next to one locked cabinet. I checked with the museum staff and was fascinated to discover that the cabinet contained a collection of items that had been left at the site of the traveling Vietnam War memorial when it had passed through Longmont. One can only imagine the quite incredible depths of emotion that would be associated with some of those articles.

When all was said and done, it turned out to be a rather interesting night. A series of knocks were heard coming from within the office, and Robbin reported seeing shadowy figures and hearing the laughter of children up on the second floor—but the laughter did not turn up in any of the digital

The rear portion of Cheese Importers, operated by the White family. *Author's collection.*

recordings, and the shadow figure sightings lack corroboration from other investigators. For his part, David claimed to be playing the equivalent of hide and seek with a male energy form, whom he believed had died somewhere between the ages of forty and sixty. The form would peek around corners and draw nearer to him but then retreat quickly when David tried to get a good look at it or make any sort of contact.

Shuffling, scuffling noises were heard coming from one of the aisles at 2:00 a.m. We were unable to pin down the source for these, despite looking for mice, rats and other varmints of a similar nature. One investigator felt a light touch on her head, while another felt the same thing upon a hand.

One team of three investigators was staking out the basement, with little of any import going on, when suddenly a foul, utterly rank odor began to permeate the room. They attempted to stick it out, but the noxious stench quickly became so intolerable that the team could no longer stand it and was forced to abandon the basement. One investigator was actually gagging on the smell. Intrigued, I quickly grabbed a team of three other available investigators and immediately led them down into the basement to see for ourselves—only to find that it smelled perfectly normal to us.

As our investigation drew to a close, I separated our two sensitives and questioned them individually about their impressions. Could they shed any light on the identity of "Stanley?"

"A male, forty to sixty years of age. No, he did not work here, and he really does not want to be discovered," David concluded. Robbin's impression was different in some aspects but also contained some similarities: there was more than one spirit haunting the building, including "a male called either Leon, Lennie, Henry or Harry, or Daniel, with the last name of Decker, I believe. A man in a white t-shirt with sleeves rolled up, wearing a hardhat and work boots. He's crouched down by a broken pipe in the basement. Also, there is a second entity: a male in a red shirt, approximately fifty years old—but this man did not work here. Neither wants to communicate or draw much attention to themselves."

Checking records did not turn up anybody with the last name of "Decker" who was associated with the premises in any of its incarnations. The fact that both sensitives described a figure aged between forty and sixty (one of them pinning it down to age fifty) who did not work in the building makes for a fascinating match. But further research was not able to narrow this down to a specific individual, and so for now, the identity of "Stanley," the name-calling, chain-rattling ghost still remains a mystery to this day.

The conversion process of the building at 103 Main Street from its role storing museum artifacts into a commercial premises (complete with eating facilities) was nothing short of an adventure. At one point, the White family was digging toward the foundations when they discovered the old diesel fuel storage tanks buried underneath the floor and not listed anywhere on the architectural blueprint. Still, Cheese Importers opened its doors to the public in the summer of 2012 and has been nothing but a raging success. But what of the ghost named Stanley?

I recently spoke with Cheese Importers proprietor Samm White via e-mail, and although he very kindly allowed me to discuss the ghost stories regarding the building at 103 Main Street within this book, he was clear about the fact that the paranormal activity seems to have died down since the building became a cheese store. Has "Stanley" simply upped sticks and moved on? Rather than the quiet air of a museum facility, the building is now full of shoppers and diners, laughing and bustling around the place. It may simply be that the new atmosphere is no longer to his taste.

My mind keeps returning to the discovery of the diesel tanks, made when the Whites dug beneath the building floor. During the time of our overnight investigation, my colleagues and I had not the slightest inkling that the fuel tanks were hidden away down there—which makes me wonder what else could be hiding beneath the building at 103 Main Street that nobody knows about.

Chapter 2

Imperial Entanglements

The Imperial Hotel, 301 Main Street

This stately nineteenth-century structure sits directly across from the grand old Dickens Building (more on which can be found elsewhere in this book). The two buildings face off against each other at the intersection of Third Avenue and Main Street, vying for domination of the downtown district.

A Prussian immigrant by the name of George Zweck (1829–1902) relocated to the United States as a young man and rode the tidal wave of the gold rush into the Colorado Territory during 1859. According to Linda Wommack's superb *From the Grave: A Roadside Guide to Colorado's Pioneer Cemeteries*, Zweck was told by a wandering gypsy that his wealth would come from the ground. Come from the ground it surely did, as the prospector's mining claims began to pay off in a big way. Left Hand Creek became famous for what became known as the "Prussian gold mine." Settling a farm to the west of Longmont and building a second summer property on land purchased up near Jamestown, George Zweck shrewdly poured the profits from his newly earned financial gains into real estate within the burgeoning city of Longmont.

Perhaps the poster child for this surge of investment was the palatial Zweck Hotel, which would one day come to be renamed the Imperial Hotel.

Third Avenue and Main Street, circa late 1800s. The Imperial Hotel and the Dickens Opera House are both visible. *Photo courtesy Longmont Museum.*

The city of Longmont had no dedicated water supply until the following year, but a hotel without flushing toilets was absolutely unthinkable, and so the Zweck hotel architect got around this by designing a trio of large brick cisterns, which were to be filled by ferrying water manually from the nearby St. Vrain River.

Heating was provided throughout by coal-fired stoves placed in alternating rooms. The Zweck was, by all accounts, a very comfortable place to spend the night. It had been fitted out with the finest imported European furniture, with carpets and mirrors throughout and polished hardwood flooring in some areas. But despite all of this relative opulence, the hotel never did recoup its initial capital investment after it was completed in 1881, and it became something of a millstone around George Zweck's neck.

Unfortunately, George's story does not have a happy ending. A series of disasters struck his business interests, causing them all to fall apart. Zweck's investments in the hotel and hospitality industry suddenly ceased to make money; his Wyoming cattle herds died off during an intense blizzard, to the tune of a staggering $90,000 loss; and perhaps most damaging of all, the gold mines in which he was so heavily invested were suddenly found to

Wedding photograph of George and Mary Zweck.
Photo courtesy Longmont Museum.

be tapped out. In a flurry of bailiffs and repossession, both George Zweck's home and business interests were taken away from him. Were it not for George's wife, Mary, who struggled to keep the family homestead and was able to make a living for the couple and their children by selling goods and produce, the Zweck family might have died in abject penury. As it was, George and Mary remained in the dual fields of farming and gold prospecting (albeit on a much smaller scale than before) until George died in 1902. Mary outlived him by another thirty-two years. The Zwecks are buried side by side at the old Burlington cemetery, located on the hill at 1400 South Sunset Street.

Faced with a ledger full of red ink, George had finally decided to cut his losses in 1894, reluctantly selling the Zweck Hotel off to Mr. and Mrs. Charles F. Allen, who promptly renamed it from the Zweck Hotel to the Imperial Hotel, bringing it into profitability at last. The Allen family continued to run the Imperial for the next half century. Following other changes in ownership, the Imperial ended its existence as a hotel in 1971. The ground floor was repurposed into small shops (a Chinese restaurant and a coffee shop can both be found there today, while the old basement is home to a Prohibition-era bar and lounge aptly named the Speakeasy), and the upper floors were converted into residential apartments.

In her book *Northern Colorado Ghost Stories*, author Nancy Hansford relates the experiences of paranormal investigators Gail and Eric Jones, accompanied by psychic medium Dori Spence, who were asked to investigate an apartment on the second floor of what used to be the Imperial Hotel. Along with the

The last resting place of George and Mary Zweck, which can be found at the rear of Longmont's Burlington Cemetery. *Author's collection.*

sensation of an invisible presence in the bathroom, the residents reported hearing the voice of a young girl in their bedroom. The voice of the young girl is particularly fascinating because it almost precisely mirrors the ghostly experience reported by Kevin Galm, owner of the Java Stop Coffee Shop, which is located on the ground floor of the same building. We will visit the Java Stop for a coffee and some spirits later in the book.

Dori Spence claimed to see two twin beds in the apartment, upon one of which was laid out the dead body of a young girl. A second young girl was seen to be crying at her bedside. Spence then blindfolded herself (as an aid to cutting out extraneous sensory input) and reported seeing the spirit of a third little girl, seemingly hiding behind the door to the bathroom, and the spirit of an adult male enter the room through a doorway that is no longer physically present, as it lay behind what is now the shower unit.

The man is said to have been a burglar, intent on breaking into the apartment from an outside fire escape and making off with any valuables he could find. When the young girl laid eyes on the would-be thief and spoke to him, he was startled and fled back down the fire escape.

It is a commonly accepted theory among paranormal researchers that locations tend to be haunted because events took place there that were infused with some very strong emotion. For example, battlefields and murder scenes are places where great fear and anger are commonplace. But it isn't always a bad thing—there are numerous accounts of ghosts returning to haunt places that they were very fond of during their lifetime, refusing after their death to completely leave behind a home or workplace that they loved very much.

Can we fathom an explanation for this particular haunting? Nancy Hasford relates Dori Spence hearing the young girl speak and offers this rationale: the young girl was waiting to tell somebody about the incident with the burglar and was willing to stay behind in the second-floor bathroom until she was able to do so.

The haunting of the Imperial Hotel makes for an interesting story, but is there any physical evidence to back it up? It turns out that indeed there is. Like all good investigators anywhere, the Joneses and Spence conducted a thorough assessment of the scene. Sheetrock mounted on the wall behind the shower unit was found to be covering the doorway through which the man was seen to have entered and left by. Moving

The old Imperial Hotel, from Third and Main Streets. Now apartments, the building is said to be haunted by a multitude of restless spirits. *Author's collection.*

to the outside of the building, the investigators found the signs of connections from where the fire escape attached to what was now the covered-up doorway.

A good paranormal investigator is always searching for the confluence of mutually supporting evidence. For example, a psychic or intuitive makes a claim of some sort—they report seeing the apparition of a man, dressed in clothing belonging to a certain historical period and engaged in some sort of activity. Research must then be done into historical records, witnesses (if any exist) must be questioned carefully and the actual scene itself must be examined meticulously. When the results of these different types of investigative techniques all dovetail together, the evidence is much more impressive than a single type taken on its own.

In this case, we have the sighting of ghostly young girls and the burglar entering through a concealed doorway from the fire escape, as reported by the intuitive investigator; the physical evidence of the sheetrock-covered doorway and fixtures of the fire escape found by the investigators at the scene; and the disembodied voice of a young girl heard by the apartment residents on multiple occasions. When taken together, this evidence makes for an interesting case that cannot be easily dismissed.

And, as we are about to learn, the second-floor apartment is not the only part of the old Imperial Hotel in which the ghostly young girls have made their presence known…

Chapter 3

THE JAVA STOP COFFEE SHOP

Also located at 301 Main Street, on the ground floor of what was once the old Imperial Hotel building, you will find the Java Stop coffee shop. Decorated in bright primary colors and festooned with animal paintings, Java Stop is a little oasis of sunshine and tranquility in the heart of Longmont's busy downtown district. It is owned and operated by a very friendly couple named Kevin and Ellen Galm.

When we met for a chat over steaming hot cups of coffee, Kevin informed me in a matter-of-fact manner that the coffee shop is actually haunted by a number of ghosts and has experienced quite the range of paranormal activity.

An officer of the Civil War era, belonging to the Confederate cause and holding the rank of major, haunts the building. According to Kevin, this particular apparition has been seen several times in the local vicinity, although the reasons behind his ghostly visits are unknown.

The ghost of a young girl also haunts the property. Although she has not been seen, Kevin clearly recalls an incident in which she spoke to him, seemingly from the thin air just over his shoulder. Could this be the spirit of the same young girl whose voice was heard in the second-floor apartment investigated by Eric and Gail Jones and Dori Spence? The type of paranormal activity (hearing a disembodied young girl's voice but not seeing an apparition) matches exactly in both cases. More intriguingly still, is this the ghost of the child who was seen lying dead on one of the twin beds, the girl who was said to be crying forlornly at

The Java Stop Coffee Shop is said to have multiple ghosts, including a male apparition seen sorting through magazines and a Confederate officer. *Author's collection.*

Inside the Java Stop Coffee Shop, where one of the owners may have heard the disembodied voice of a young girl. *Author's collection.*

her bedside or perhaps the ghost of the girl who startled the burglar in the bathroom?

Like the excellent hosts that they are, Kevin and Ellen like to leave newspapers and magazines for their customers to peruse as they enjoy their coffee and pastries. In her book *Northern Colorado Ghost Stories*, Nancy Hansford relates the story of a server in the coffee shop who frequently opened up the store by herself at the beginning of the business day. On no less than three separate occasions, she witnessed the same apparition: a man of around fifty years of age, leafing through the stacks of magazines and newspapers—until the server's gaze fell upon him, and he disappeared into thin air.

Chapter 4

WHAT THE DICKENS?

THE DICKENS OPERA HOUSE AND TAVERN—300 MAIN STREET/ THE DICKENS MANOR APARTMENTS—303 COFFMAN STREET

Arguably Longmont's best known building, it is a rare city resident indeed who hasn't taken a seat and enjoyed a meal or a drink in the historic Dickens Opera House and Tavern at some time in his or her life. Situated at 300 Main Street—right at the busy intersection of Third Avenue and Main Street—the Dickens Tavern and Opera House faces the Chinese takeaway restaurant and apartments that once were home to the old Imperial Hotel.

The Dickens Tavern's website proudly announces the familial link between Tavern and Opera House builder and owner William Henry Dickens and the renowned author of *A Christmas Carol, David Copperfield, Oliver Twist* and numerous other classic works of English literature, Charles Dickens (William Henry Dickens's mother was married to the great author's grandson). The Dickens family were highly influential landowners in and around the Longmont area during the 1860s—indeed, the Dickens Opera House was constructed upon ground that was gifted to William Henry Dickens's father by none other than Ulysses S. Grant, the eighteenth president of the United States.

Construction on the Dickens Opera House was completed in 1881, and the building has fulfilled a number of diverse roles throughout its

The Dickens Tavern and Opera House, as seen from Third Avenue. *Author's collection.*

lifetime, including that of a bank (you can still see the original bank vault today) and Longmont's first college. William Dickens was a man of wealth, education and culture who wanted to spread a little of that culture with his fellow Longmont citizens, and so, the Dickens Opera House was conceived.

Dickens had quite the colorful and storied past. As a young man, he had served with the Colorado Third Cavalry Regiment, ironically nicknamed "The Bloodless Third" due to their lack of battle experience. On November 29, 1864, "The Bloodless Third" earned a new nickname when they attacked a peaceful gathering of native tribespeople (mostly Cheyenne) who had taken up residence in the bend of Sand Creek: they became known as "The Bloody Third." With the vast majority of fit males away on a hunting trip (having being reassured by the U.S. authorities that their families would remain unmolested), the camp was composed primarily of women, children, the elderly and the infirm.

Under the command of Colonel John Chivington, the Third Cavalry (needlessly reinforced by elements of the First Cavalry Regiment, First Regiment New Mexico Volunteer Cavalry and an attachment of artillery) descended on

the camp without warning. Two companies did not participate due to a point-blank refusal on the part of their officers to attack noncombatants, but the remainder offered absolutely no quarter. Most troopers had gotten falling-down drunk the night before and were in no mood for mercy the following morning.

Colonel Chivington himself was a zealous Methodist preacher who advocated nothing less than a policy of genocide against the Native American tribes whom he so violently detested. This perhaps goes some way to explaining why the aftermath of the massacre descended into even worse atrocity, as the cavalrymen set about the corpses of their victims with knives, axes and sabers. Fingers, toes, hands, feet, scalps, noses, eyes, ears, tongues and even testicles were hacked away and taken as obscene trophies.

William Henry Dickens. *Photo courtesy Longmont Museum.*

When the gun smoke had faded and the screaming had stopped, Chivington's ludicrously inflated claim to having killed almost six hundred warriors failed to withstand even the most cursory scrutiny. Although eyewitness accounts vary, what modern historians agree upon is that the butcher's bill stood somewhere between 125 and 180 victims, with about 80 percent of the victims being the almost defenseless womenfolk, the elderly and children. Unbelievably, the United States Congress Joint Committee on the Conduct of the War official report states that the soldiers turned the carved-up body parts of their victims (including the genitalia and even some fetuses) into grisly decorations for their uniforms and weaponry.

National condemnation of the atrocity that had taken place in the Colorado Territory soon spread like wildfire, and the incident gained the informal name of the "Sand Creek Massacre." This was not helped in the slightest by the actions of certain cavalry veterans, who for months afterward were proudly displaying the hacked-off digits, appendages and

scalps to the patrons of various Denver-area drinking establishments and even to theater audiences.

Despite censure from their superior officers, neither Colonel John Chivington, nor any of the soldiers under his command were ever formally punished for their actions at Sand Creek. William Henry Dickens's role in the Sand Creek Massacre remains unclear, and one is forced to wonder whether he was haunted by those events for the rest of his life. What is known is that after leaving the Third Cavalry Regiment, Dickens settled in Longmont, married, fathered five children and set about the task of becoming a major force in the fields of freight transportation, banking and commerce.

Built in 1902, what is now known as the Dickens Manor apartment house at 303 Coffman Street (the intersection of Third Avenue and Coffman) was, back in 1915, home to William Henry Dickens and his wife, Ida. It was past dark on the night of November 30, and both William and Ida were sharing a companionable silence while reading together in their expansive library room. William was positioned with his back to the window. Without warning, the darkness shrouding the alleyway outside was torn by the flash of a rifle muzzle as it expelled a single high-velocity round through that very same window. The bullet took Mr. Dickens in the back before blowing straight through his torso and burying itself in a wall. Accounts vary as to whether a fragment of the bullet happened to spall off and graze Ida Dickens on the cheek, or perhaps it was a chunk of metal button from William's jacket. What is known is that before the horrified eyes of his helpless wife, William Henry Dickens bled to death within minutes on the floor of his own library.

Police officers from miles around descended upon Longmont in a vain attempt to find the assassin. Theories abounded about who had killed William Henry Dickens. A local man with whom he had recently quarreled had murdered him; Native Americans, biding their time for decades, finally chose their moment to seek retribution for his participation in the Sand Creek Massacre (never mind the other perpetrators of that brutal affair, numbering around one thousand men!); the brother of a criminal who had been killed by a posse of which Dickens had been a member, seeking vengeance on the most prominent of his executioners; maybe a gang of local toughs, resentful at Dickens's role in their arrest and prosecution; a disgruntled employee; or perhaps simply a rival banker or businessman—after all, one does not reach the stature in the financial world of William Henry Dickens without making one or two enemies along the way.

The alley in which the murderer of William H. Dickens lurked before firing a rifle through the library window. *Author's collection.*

And so it came as quite a surprise when the police arrested their number one suspect and charged him with the murder: William Henry Dickens's own son, Rienzi.

On the face of it, the evidence stacked up against Rienzi Dickens was rather damning. Once detectives began delving into his recent activities, they soon discovered that he had recently purchased a brand-new high-velocity rifle and ammunition, less than a month prior to the murder of his father. There was also a silencer, an odd choice, to say the least, if the rifle was intended for hunting or other recreational uses. Rienzi's whereabouts on the night of the murder could not be accounted for, and his protestations of innocence began to sound increasingly feeble as new pieces of incriminating circumstantial evidence started to come to light.

Detectives turned over Rienzi's home in a search for evidence. A portion of the rifle was found in his home, along with a box of ammunition (some of which was missing). The silencer was discovered hidden upstairs in the house and the rifle barrel in a barn a block away from his house.

Why break the rifle down into individual components and then stash them in different locations? A smarter approach entirely would have been to drop the entire rifle and its ammunition into the St. Vrain River or some other body of water, where it may not be found for some time—if ever. With the rifle being purchased a few weeks before what began to look like a premeditated murder, why not use the time wisely and establish an alibi? Or purchase the rifle illegally, leaving no trail to a firearms seller for the police to find? Worse still, in one of Rienzi's initial interviews with police officers, he denied even purchasing or owning a rifle—until, confronted with the proof, he recanted.

If Rienzi Dickens was a murderer, he does not appear to be a very intelligent one. Is it possible that he was framed by the real murderer?

In the case of a homicide, investigating detectives search to uncover three things: means, motive and opportunity. It was undeniable that Rienzi Dickens possessed the means and the opportunity, but did he have the motive? His financial situation was rather dire; he was nearly $40,000 in debt. There was a case to be made that Rienzi stood to inherit a considerable sum of money in the event of both his parents' deaths. Given contemporary reports that state that Ida Dickens had only just walked into the library and taken

a seat close to her husband when the fatal shot was fired, it is certainly possible that the killer waited until the chance presented itself to shoot both Mr. and Mrs. Dickens with the same round. Ida was certainly wounded in the incident, although not seriously. Did the murderer hold his fire until she had reached an advantageous position?

Despite the confluence of evidence arrayed against him, Rienzi maintained his

Ida Kitely Dickens, wife of William Henry Dickens. *Photo courtesy Longmont Museum.*

The grave site of William H. Dickens and his wife, Ida. They are buried together at Mountain View Cemetery. *Author's collection.*

innocence until his dying day. His family agreed with him, rallying around in support against the charges, even going so far as to post bail on his behalf and fund a bevy of private investigators in an attempt to track down the real culprit. They came up with a suspect in the form of a local man named John Endsley, though the case never really held any water.

The case against Rienzi Dickens went to trial the following year. Given the prominence of William Henry Dickens in the Longmont community and its surrounding areas, all eyes were on the proceedings. Rienzi's attorney received an anonymous letter in the mail proclaiming Rienzi's innocence and claiming that the author had shot Mr. Dickens due to an unspecified personal grudge against him and then walked north to Loveland and buried the rifle when he got there. The jury was evidently unconvinced. The trial culminated in a guilty verdict against Rienzi, convicting him of second degree murder.

The plot thickened once again when the Colorado Supreme Court overturned the conviction, setting a second trial for 1921. This time, the result was an acquittal, and Rienzi walked free. He immediately relocated to Long Beach, California, dying there some forty years later. To this day, the case is considered to be unsolved, although theories and speculation still abound.

Readers interested in the true intricacies of this case are encouraged to read Carol Turner's article "The Mysterious Death of William H. Dickens," which is almost certainly the most meticulously researched and readable account of the entire affair.

Which brings us to the ghost stories.

The once-palatial Dickens Manor, currently subdivided into apartments. *Author's collection.*

The building in which William Henry Dickens met his death is now subdivided into a series of apartment buildings. Anecdotal stories pop up from time to time about the building being haunted, supposedly by a dark and blurry male figure presumed to be that of Mr. Dickens. As an EMT working in Longmont ten years ago, I heard several variations on this from occupants of different apartments at Dickens Manor. But there is little concrete testimony, and the stories may be more of the urban legend types that often crop up around the scene of a violent death.

But the Dickens Opera House has a long and well-attested history of paranormal activity, something of which the current owners make no secret at all. They post accounts of ghostly goings-on at the building's website, www.dickenstavern.com, which serves as the primary source for some of the following accounts. Indeed, if a visitor scrutinizes the wall of authentic period photographs inside, they will see what some believe to be the headless torso of a serving girl floating in front of one of the windows.

Downstairs in the Dickens Tavern, the ghost of a young girl is said to haunt the basement. When alone in the building one night after close of business, owner Sean Owens was in the midst of completing the nightly paperwork when he heard the sound of a door opening or closing. Puzzled, Sean stuck his head out of his office to peek into the corridor. Nobody was there.

The owners of the Dickens Tavern maintain a historic photograph wall, one of which seems to show the apparition of a dog. *Author's collection.*

Performers from the Dickens Opera House, circa 1890. *Photo courtesy Longmont Museum.*

Sean continued to explore the basement, working on the premise that perhaps one last customer had gotten accidentally locked in when the staff closed up the building. Still nobody was to be found. Then Sean turned a corner and flipped on the lights, only to find the contents of the chef's cooler strewn all across the kitchen. Could this be the work of the young girl or some other restless spirit? It is claimed that during the early years of the Dickens Tavern and Opera House, the homeless people of Longmont were permitted to sleep in the building for warmth and even to eat the leftover kitchen scraps in exchange for helping to clean the place up after parties and social functions. Could this messy poltergeist activity be a leftover remnant from those bygone days?

From where do we get the story of a little girl haunting the basement? Evening floor manager Gary Brennan was recently asked to attend to a pallid, rather shaken female diner at the request of her husband. The female diner went on to tell Gary that as she had been heading to the downstairs restroom, she had encountered the apparition of a young girl. Living woman and dead girl both locked eyes, and the girl transmitted a

The cozy and intimate wine vault inside the Dickens Tavern. Where else could you be waited on by a ghostly host? *Author's collection.*

wave of sadness, pain and terror through the medium of their fixed gaze. The diner described the experience as one that was "so sad and lonely and terrifying."

Gary had no problem believing the rather frightened customer, as he had witnessed the apparition himself on a prior occasion. In fact, some members of staff have begun to affectionately refer to her as the "Dickens Darling." One of the charming relics left over from the Dickens's historic past as a banking establishment is the leftover bank vault, now converted into a wine storage vault. Dickens Tavern lore states that an unhappy member of staff committed suicide in the vault many years ago.

Catching a glimpse of a female staff member heading into the vault, Gary ducked in behind her in order to ask a question. Like any bank vault, there is only a single way in and a single way out—which makes it all the stranger that there was nobody to be seen when Gary stepped inside. He wasted no time in exiting, only to find the hostess who he had been seeking entering the tavern from outside, where she had been watering plants all along.

Moving upstairs from the Tavern into the Opera House itself, Gary has a spine-chilling story to tell involving the Green Room, the area located directly behind the stage that is set aside for the guest performance artists

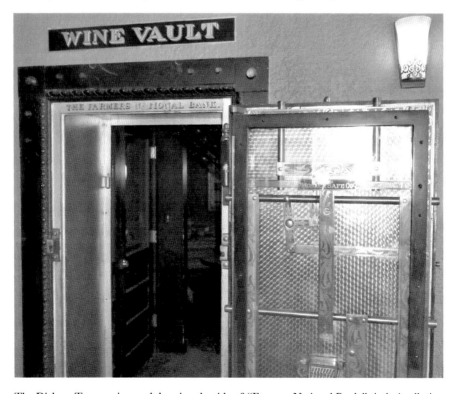

The Dickens Tavern wine vault bearing the title of "Farmers National Bank." *Author's collection.*

who regularly grace the Dickens with live music and entertainment. As Gary relates the story, he was working a fourteen-hour shift and was so tired that he decided to take a power nap on the couch in the Green Room. Tired as he was, Gary had no problem drifting off to sleep, but he was awakened by the sound of children laughing and playing, somewhere either on the stage or perhaps out on the dance floor.

Concerned in case somebody had broken into the Opera House, Gary immediately went to check out the noises. He searched high and low, poking into all of the out-of-the-way places where only an experienced staff member who possessed an intimate knowledge of the building would think to look. No trespassers were found, but the noises continued to intermittently accompany Gary's search in what sounded like a teasingly playful way. Trying once again to sack out for some much-needed sleep, Gary had no sooner closed his eyes when he could hear the pitter-patter of running footsteps once more.

Mentally begging the spirits to leave him in peace and allow him to sleep, Gary was instantly rewarded with the sound of a storage door (which was padlocked) beginning to slam against the lock, as though something were attempting to escape. Gary felt compelled to flee the place immediately and wasted no time in doing so.

He makes a point of ending his story with a warning. The majority of paranormal experiences that are reported in the Dickens Opera House and Tavern are perceived to be either harmless or even positive in nature, Gary says. But this particular part of the building felt so negative to him that he will no longer spend time in that room on his own.

The Dickens Opera House website also tells the story of its new talent buyer, a woman by the name of Laura Hofford Wilder. According to Laura, she was fetching some audio equipment from the storage area, which is located next to the Green Room. As she turned back around, Laura saw a solid white apparition pass by directly in front of her, crossing the hallway at a distance of about eight feet.

A logical explanation would be that Laura witnessed a living person crossing the hallway in front of her, especially when taking into account the fact that the figure was walking from one doorway to another. But what is most remarkable about this sighting is that both doors—the one from which the figure seemed to enter the hallway and the one from which is appeared to exit—were closed when Laura stepped forward to check. She had not seen either of them open or close.

Firemen of the Buckingham Fire Department parade outside the Dickens Opera House, circa 1890. *Photo courtesy Longmont Museum.*

As with so many reputedly haunted houses, it can be challenging for the historian or paranormal investigator to separate fact from lore and legend. One such story involves the period in which the Dickens was still a functioning opera house, with amateur dramatic performances taking place on a regular basis. According to a 2003 article in the *Coloradoan*, an actress dumped her beau in favor of another man with whom she was performing in the same play. When her original suitor found this out in the least pleasant way possible—catching the pair together backstage—he reacted violently, stabbing both lovebirds. While the actress survived the attack, her newest beau died of his wounds. If the story contains a kernel of truth, could it perhaps explain the mysterious figure in white seen crossing the upstairs corridor by Laura Hofford Wilder?

I heard a variation on this story myself when I interviewed Dickens Tavern and Opera House staff several years ago. In the version that I was told, the love-struck young lady was the wife of the knife-wielding attacker. Two staff members related a sensation of feeling icily cold when they were standing on the Opera House stage and attributed it to the spirit of the dead actor, trying to attract their attention.

I cannot help but think (once again, assuming that the story has any truth to it) that the violent slamming of the padlocked storage door reported by

The cast of a play conducted at the Dickens Opera House, circa 1885. *Photo courtesy Longmont Museum.*

Gary Brennan might bear some relation to the rage, frustration and terror felt by the participants of the tragic offstage drama.

Longmont resident Dori Spence, who runs paranormal sightseeing tours around the city and claims to possess the ability to see and sometimes interact with ghosts and spirits, is said in the book *Northern Colorado Ghost Stories* to have conversed with the spirit of a homeless man who, along with a group of homeless friends and acquaintances, was allowed to spend nights at the Dickens as a kindness, so long as they left the building before daybreak.

She also relates the presence of a female ghost, rocking back and forth in a rocking chair as she reads stories to children who are no longer there, and the ghost of an Irishman who sang "Danny Boy" to her from his vantage point on the Dickens Opera House stage.

The investigators from the Boulder County Paranormal Research Society (along with guest investigators from a couple partnering agencies and a reporter from the *Longmont Times-Call* newspaper) wanted to examine the stories of ghostly activity at the Dickens Tavern and Opera House, which is

why we found ourselves conducting baseline tests throughout the building on a sunny October day back in 2008.

We found nothing remarkable when it came to the electromagnetic energy field levels, temperatures or air ionization levels. Things started to take a turn for the unusual when we heard a clanking sound originating from the rear of the dining area. Although nothing was obviously out of place, some on-the-spot testing determined that the clanking noise almost exactly mimicked that of a piece of cutlery being dropped onto a tabletop. A large tray of cutlery was placed against a wall at the back of the dining room, which may have been the source of the noise—except that the dining area had been empty at the time.

Independently of one another, three investigators reported a feeling of unease or discomfort when standing against that same back wall. Highly subjective, to be sure, but interesting nonetheless.

The elevator door began to open and close without the call button being pushed. This happened a total of six times, and the owner told me that the elevator had been maintained properly and declared mechanically sound just a few weeks prior to our visit.

The south entrance of the Dickens Opera House, where investigators debunked the apparition of a figure standing at the bar. *Author's collection.*

Shortly afterward, footsteps were heard on the staircase leading down to the basement (the staircase on which, in later years, a diner would report seeing the ghostly form of the "Dickens Darling") when nobody was standing on it.

We did manage to find a non-paranormal explanation for one of the Dickens Tavern apparitions. A male bartender had reported seeing the jacketed figure of a man sitting at the bar or standing in that area when they arrived in the morning to open up the building at the start of the workday. When the bartender stepped through the inner door into the Tavern, the figure had disappeared.

As the sun rose higher in the sky, my fellow investigators and I took turns stepping into the door through which the bartender entered the Tavern and noticed something intriguing. The rays of the sun (when not covered by the overcast cloud cover) shone through the glass of the outer door, then through the glass of the inner door when a person stepped through it on their way into the Tavern itself. For just an instant, a reflected image of the person could be seen flashing across the mirror located behind the bar and appearing for all the world as if a separate figure were standing or sitting

The bar at the Dickens Tavern. *Author's collection.*

The front door and awning of the Dickens Tavern. *Author's collection.*

in the vicinity of the bar. This particular ghost turned out to be nothing more than a trick of the light, which explained why the "apparition" had never been reported after dark. Our hats went off to guest investigator Erik Colnick for this superlative bit of debunking.

But reflected light anomalies aside, the Dickens Opera House and Tavern are still home to a wide array of ghostly stories. The next time you happen to be passing the intersection of Third Avenue and Main Street, it would be worth your time to take a visit. Pull up a seat at the beautifully-crafted marble bar, and ask the bartender or hosting staff what latest paranormal escapade has come close to scaring the Dickens out of them.

Chapter 5

FRIENDLY SPIRITS

THE ST. VRAIN MASONIC LODGE—312 MAIN STREET

The Masonic Lodge stands directly next door to the Dickens Opera House and Tavern. One would be tempted to believe that being an immediate neighbor to such a haunted building as the Dickens might cause some of that paranormal activity to bleed across, through the very walls themselves—and one would be correct.

Paranormal investigators Gail and Eric Jones of Spirit Connection Investigations were fortunate enough to spend a night investigating claims of ghostly activity inside the Masonic Lodge. Gail and Eric told me that the Masonic brothers are rather fond of their resident ghost and have no wish for him to leave.

The story goes that, many years ago, one of the Masons collapsed while climbing the staircase due to suffering a massive heart attack and died at the very top. His apparition has been seen by a significant number of the Longmont Masons in various places throughout the lodge. He is said to be a friendly, well-intentioned ghost with no desire to harm anybody.

Another equally friendly ghost is the playful spirit of a young boy named Silas, who seems to want nothing more than to gain some attention and perhaps to play. The team from Spirit Connection Investigations had kindly agreed to allow a small group of students to accompany them on

The doorway to the Masonic Lodge on Main Street, said to be haunted by the spirit of a young boy and a former lodge member. *Author's collection.*

the investigation. Various control objects (items of significance that are intended to entice spirits into moving them) had been employed, including a ball that had been placed on top of thick carpeting. Throughout the night, the ball had stubbornly refused to move.

One of the visiting children was attempting to talk to the ghost of Silas, asking him to play. Then, seemingly out of the blue, the ball suddenly began to roll, ending up some three feet away. Fortunately, the incident was caught on infrared video, and you can view the footage over at SCI's website, www.spirit-investigations.com.

A medium who was accompanying the SCI team said that she was able to communicate with Silas, who she said had told her that he was not attached to the Masonic hall itself but rather was haunting the general area. In life, his father had worked on the Main Street of Longmont in various capacities during the early nineteenth century. The medium suddenly staggered forward, clutching at her head. Silas had smacked her playfully on the back of the head, she said, astonished. She had never been touched by a spirit before, and so this came as quite a shock to her. But Silas did not want to harm anybody, she emphasized. He was simply a lonely and playful little boy, enjoying the gift of some unexpected company.

Chapter 6
THE LADY ON THE LAWN

THE CALLAHAN HOUSE—312 TERRY STREET

Thomas Callahan is one of those great historical characters whose life and work deserves to be more widely known. Together with his wife, Eliza Alice (who went by "Alice"), Thomas Callahan was a highly influential figure along the Front Range of Colorado during the late nineteenth and early twentieth centuries.

He was born in Chillicothe, Illinois, in the year 1857. He dabbled in the fields of teaching and photography, which afforded him the opportunity to travel. It was on these travels that Thomas Callahan encountered the woman he was later to marry: Alice Barnett, the daughter of a banker.

The newly married Mr. and Mrs. Callahan made their new home in Longmont in 1889 and, after some deliberation, set out on their first venture: the Golden Rule.

The "Golden Rule" was the name of Callahan's chain of stores, which prospered through selling dry goods and clothing. Callahan funded and administered the chain of eighteen Golden Rule stores spread across five states, with the help of a consortium of his family, friends and neighbors, which included more than one former employee of his who had started at the bottom of the ladder as a store clerk before working his way toward prosperity.

Such a man was James Cash Penney (better known to modern-day Americans as J.C. Penney, after whom the national chain of retail stores is named), who

was running a small food store that combined the functions of butcher's shop and bakery. He made a decent enough living until he fell afoul of the head chef at a local hotel. The man tried to get Penney to bribe him with free whiskey in exchange for securing the hotel's business. As a deeply devout and religious man, this did not sit well with the young J.C. Penney, but he reluctantly caved in to the demand. When the time came round to renew the order, Penney went with his conscience and took the moral high ground, refusing to pay the bribe a second time. There were to be consequences for taking this ethical stance—and his financial situation suffered accordingly when he lost the hotel's custom, on the say-so of the corrupt chef. The food store went out of business, forcing J.C. Penney to take work as a clerk at Thomas Callahan's Longmont Golden Rule store in 1899.

Thanks to the buying syndicate that Callahan

Top: T.M. Callahan, approximately sixty years of age. *Photo courtesy Longmont Museum.*

Left: Alice Callahan in her wedding dress. *Photo courtesy Longmont Museum.*

set up with his partners, the Golden Rule stores were able to buy stock at a significant discount and pass that saving along to the customer, while still turning a healthy profit along the way. The retail corporations of today could learn a lot from the way Thomas Callahan did things! The name "Golden Rule" became synonymous with the selling of high-quality merchandise for a reasonably low price, and it wasn't long before the chain of stores dominated the market throughout Colorado and the Midwest.

Thomas Callahan and his business partner, Guy William Johnson, were both extremely impressed with the young J.C. Penney's industriousness and strong work ethic, and it was therefore inevitable that they would offer him a one-third partnership in one of their new Golden Rule stores, located in Kemmerer, southwestern Wyoming. Penney didn't need to be

A plaque commemorating the original site of J.C. Penney's meat market on Main Street. From tiny acorns... *Author's collection.*

asked twice, ponying up the $500 from his life savings and borrowing the remainder of the $2,000 asking price. It turned out to be a shrewd move on the young entrepreneur's part: the Kemmerer Golden Rule store would be the birthplace of the J.C. Penney Corporation in 1913. Thomas Callahan would ultimately sell forty-six dry goods stores to J.C. Penney, whose own

The snow-bound driveway at the Callahan House, specially constructed for one of the first automobiles ever to roam the streets of Longmont. *Author's collection.*

business empire would grow to encompass more than one thousand stores throughout the United States and Puerto Rico. For as long as he lived, J.C. Penney regarded Thomas Callahan as a mentor and role model.

As the Callahan business prospered, Thomas and Alice welcomed a son, Raymond, to their family in 1894.

What the citizens of Longmont today know of as the "Callahan House" was actually built for a man named J.K. Sweeny in 1892. Thomas Callahan purchased the house from Sweeny in 1896, in a deal that involved not just cash but also a massive shipment of lumber (seventeen train cars full!) that Sweeny used to build a new flour mill in the city of Pueblo.

The Callahans saw a great deal of potential in their new two-story home but found it to be a little on the primitive side for their tastes. This was easily fixed, with a slew of modifications and upgrades to the brick building. There was no running water, so indoor plumbing was a necessary early step, with running hot and cold water an absolute must. Central heating was installed to help offset the freezing Colorado winters, and the house was wired with an electrical supply, by no means a commonplace feature in those days. All of this added up to make the

Callahan House an absolute exemplar of modernity at the close of the nineteenth century.

Walking around the Callahan House today, it takes very little imagination to place oneself back in the days in which the Callahan family was still in residence. Much of the décor has survived, particularly the antique wooden furnishings. To step through the front door is almost to step back in time itself. But before visitors get to the front door, they have to negotiate the grounds, which look like something dreamed up in a fairytale.

Until 1906, the grounds were considerably smaller and more cramped than they are today. But Alice took the opportunity to purchase the plot of land adjoining the Callahan House to the south and a smaller strip of land to the north, had the small house that was standing there demolished and landscaped the remains. There is a distinctly mythic theme to the gardens that survives to this day, as the carved stone fountain and statuary mounted on plinths represent the figures of Pan, Artemis and Bacchus.

The Callahans were a very progressive, forward-thinking couple, so it should come as no great surprise that they were one of the first families in the city of Longmont to own a newfangled contraption known as an

Looking through the awning at the side of the Callahan House toward the garage and drivers' quarters. *Author's collection.*

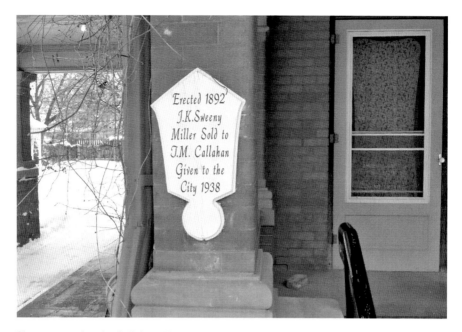

Plaque entrusting the Callahan House into the care of the City of Longmont. *Author's collection.*

automobile. They built a dedicated garage in which to house their pride and joy, complete with a turntable built into the floor (not all automobiles had a reverse gear in those days) and sleeping quarters for the chauffer whom the Callahans employed, located up above the garage itself.

By all accounts, the Callahans lived a happy and relatively uneventful life in the house. In 1938, the house was transferred to the ownership of the city of Longmont, where it remains to this day. Mrs. Callahan was adamant that the house be used to further the social life and education of the city's women.

Historical research has revealed no great tragedy associated with the Callahan House that might explain the ghostly activity reported there by staff and visitors alike, but it is most undoubtedly haunted.

Sitting in one of the spacious upstairs rooms is a beautiful walnut piano, a gift from Thomas to Alice for the Christmas of 1896. There are numerous accounts of the piano seemingly playing itself or at least the sound of piano music emanating from the room in which the piano can be found. It is still in perfect working order, having been refurbished with painstaking care in 2002.

The historic Callahan House, as seen in March 2015. *Author's collection.*

During a paranormal investigation, a team from Lockdown Paranormal captured what they believe to be the sound of piano music emanating from Alice's former bedroom, which houses the Steinway piano today. The same team also captured several EVPs over the course of its experimentation sessions and is convinced that they belong to Raymond Callahan, Thomas and Alice's son. The EVPs seem to share a common theme: wanting the investigators to leave. Readers can judge this for themselves by heading over to the Lockdown Paranormal website, found at http://www.lockdownparanormal.com/callahan-house.html.

On a brightly moonlit night in the spring of 2014, I led my own overnight investigation into the haunting of the Callahan House. My colleagues from the Boulder County Paranormal Research Society (BCPRS) and I, accompanied by several of our friends from the Other Side Paranormal Investigations and a scattering of City of Longmont employees, secured permission from the city authorities to spend the night there.

We had already heard about the piano music originating from an empty room. I was told that, on several occasions, the intruder alarm system (triggered when one of a number of motion sensors is activated by a moving

person or object) was activated in the middle of the night when the Callahan House was all locked up and empty. When police officers responded to the alarm, the building was found to be completely empty.

On a similar note, there are other instances of the alarm system being triggered and the front door being found unlocked and swinging open. Yet again, the building always turns out to be empty. There are never any signs of theft or vandalism on the property or grounds.

But by far the most interesting aspect of the haunting is the apparition. Several witnesses have reported seeing the figure of a woman, who seems to be wearing a vintage flowing dress or nightgown, standing in the second-floor window, which faces out onto the spacious front lawn. It has been speculated that this is the apparition of Alice Callahan, perhaps returning to the place where she was happiest in life. But an alternative theory was advanced by a member of the staff who wandered aloud whether Mrs. Callahan might actually be registering her disapproval at the fact that her former home is no longer exclusively used by the ladies of Longmont.

Of particular interest was a black-and-white photograph that one of our investigators found in an upstairs bedroom. Dating to sometime around the beginning of the twentieth century, it shows the Callahan family proudly

The Callahans with their 1913 Detroit Electric Car. Thomas and Alice are inside the car, and their son Raymond is standing outside. *Photo courtesy Longmont Museum.*

posing with their shiny new automobile on the strip of driveway in front of the house. What caught the investigator's eye was what appears to be the figure of a dark-haired woman standing in a front window on the second floor—the window in which the female apparition has been reported. The figure seems to be wearing a white-colored dress or nightshirt, with dark hair flowing down over the shoulders.

It's possible that the figure (if it actually *is* a figure) is a simple trick of the light, explainable by pareidolia (the human mind's tendency to see human-shaped patterns in natural reflections and shapes), but nothing similar appears in any other window of the Callahan House in this same photograph.

Because we had a few minutes of daylight left, our team spent the time trying to recreate the photograph. BCPRS investigator Anna Choate was hurriedly wrapped in a spotless white tablecloth and pressed into service as a makeshift model, standing in the same window as the figure while we took photographs of her from the lawn outside. The resulting photographs bore a striking similarity to the framed monochrome photograph.

Using a full-spectrum camera (a camera that captures both visible light and light from the near-infrared portion of the spectrum), BCPRS investigator Linda Fellon recorded a fascinating anomaly on three of the many digital photographs. Night had fallen at this point, and a purplish shape appeared superimposed over the ground-floor window directly beneath that in which the female apparition has been reported. The next frame is the most intriguing of all, showing a purple form that looks rather like the bell-shaped form of a woman wearing a hooped skirt or dress. This photograph has caused no small amount of debate among the investigators present that evening and the colleagues we have consulted for a second opinion. Some believe it is simply lens flare from the house lights (although it does not appear in the next frame, taken a split second later—the anomaly has completely disappeared) that is being mistaken for a female form, whereas others, myself included, believe that Linda may have captured two frames of a moving energy form of some kind, passing from west to east on the lawn of the Callahan House.

It was to be an eventful night. Investigators were divided up into teams and situated on different floors of the Callahan House, including the basement and the carriage house, which had once stored the automobile. Three separate sets of camera batteries were drained completely empty over the space of just a few minutes, a not-uncommon occurrence in haunted locations. A Rem Pod (a type of EMF meter that flashes a sequence of colors

depending on the strength of the field being detected) situated in an empty room on the second floor began to flash and flare without any apparent cause, indicating the presence of an electromagnetic field for which an origin could not be accounted. This would happen at several other times throughout the night.

The team members that were tasked with investigating the carriage house were experimenting with an Ovilus (a device that measures electromagnetic activity and equates a specific level of energy to a word listed in a vocabulary database), and when they asked, "Which is your favorite part of the house?" they were rewarded with the answer, "Outside." The same investigators heard what sounded like a male voice, muttering something indiscernible in the driver's sleeping quarters.

The Ovilus seemed to claim another hit when it came up with the words "Steven" and "mirror." None of the investigators realized until later on in the evening that there was a mirror upstairs engraved with the phrase, "In loving memory of Steven Jessen." We were told by city employees that Steven Jessen is the name of a former administrator of the Callahan House.

Down at the coordination station, located in the dining room on the ground floor, I was manning the radios with fellow investigator Joey Stanford. At the stroke of 10:00 p.m., we began to hear the sound of heavy footsteps thumping across the floor above our heads, accompanied by a solid thump and noises similar to a large object being dragged across the floor. We verified that nobody was stomping around upstairs; the team investigating up there was static, not moving around a great deal. We would learn just a short while later that at 10:00 p.m., a member of the upstairs team had challenged any spirits present "to go downstairs and mess with Joey." Immediately after this, the footsteps began—big, loud, heavy footsteps on the ceiling above us that nobody on that floor heard but were crystal clear to Joey and I in the dining room beneath.

Just as Joey called a break to the investigative session over the radio, the Ovilus upstairs chimed in with, "Break!" We spent a little time sending two investigators upstairs to try to reproduce the thudding footsteps, but even their heartiest efforts at jumping through the floor resulted in only the faintest of noises through the stout wooden floorboards.

After a few minutes of downtime and some refreshments, the teams went to different locations. The Callahan House had mostly cooled down after the warmth of the day, and we were hearing virtually no clinks and groans of building contraction as the clock started to creep up on midnight.

Fleeting footsteps were heard on the dining room staircase, accompanied by indistinct talking and giggling. The footsteps would return again, shortly after one o'clock, followed almost immediately by a shadow form glimpsed fleetingly on the same staircase.

Out in the carriage house, two investigators reported hearing a deep growl, which they described as seeming to come from a male throat. A cabinet door, known to have been closed earlier, seemingly opened itself in front of an investigator.

Down in the basement, an investigator and a city employee were in the middle of conducting an EVP experiment when what both described as an amorphous black cloud drifted across their field of vision, passing through a wall. Both ladies were so startled that by the time a camera was fired up, the cloud was gone.

Further investigation down in the basement revealed no sign of the elusive black cloud, and the investigation wrapped up just before sunrise. All of the participants agreed that there was ample reason to believe the historic Callahan House has more than its fair share of ghostly activity.

Chapter 7

CURL UP AND DYE

HAIR SALON—UNIDENTIFIED LOCATION IN EAST LONGMONT

Located in a rather unremarkable strip mall in the eastern part of Longmont is an innocuous-looking hair salon whose staff and customers have reported a rash of unusual activity.

Hairdressing supplies such as dyes, shampoos and conditioners are kept in a back room for storage. Shortly before six o'clock one evening, the owner of the salon was preparing to dye the hair of a pregnant customer. The two ladies were chatting happily, and after a few moments spent preparing the client's hair, the owner made her way into the storage room in order to mix up the necessary dye coloring.

At first, she wrote off the sounds of movement inside the room as being nothing more than her imagination playing tricks on her. She continued to mix the coloring and stepped back out to place it next to her customer.

"What's happening in there?" the customer asked curiously. Both ladies could hear movement coming from within the storage room now. "It sounds as though some boxes are being moved or something, but I thought you were the only person back there."

The two ladies, client and owner, went to check out the storage room together. Boxes of product were moving, ever so slightly but quite definitely,

without any human hand to push them. And then the ladies began to hear noises—taps, knocks, clicks and shuffling—coming from all around the deserted front desk, situated directly behind the main entrance door.

This particular salon had already garnered a reputation for being haunted, shared as a bit of an inside joke among the owner, the staff and a few regular customers who had witnessed some bizarre occurrences.

The salon owner and staff had grown accustomed to inexplicable sounds when they worked in the building after nightfall. "But things like that usually don't start in here until later at night," the owner told me during our interview.

The pregnant client was sufficiently creeped out by the noises and moving boxes to leave the salon immediately, forgoing her hair-coloring appointment.

"And it was at that point," the owner told me, "that I heard the howling sound come from right in the middle of the storage room." Quite understandably, she locked up the salon, went home for the night and broke out a bottle of wine.

"I'm wondering if it's because the client was pregnant," the owner told me in an e-mail. There would soon be reason to suspect that this might be very near the mark.

The activity was not restricted just to the salon. Employees of other businesses in the strip mall also began to report strange occurrences. One employee who worked several doors down from the salon stated in a very matter-of-fact way that her office "sounds like a bowl of Rice Krispies after eight o'clock at night," with unexplained sounds emanating from the walls, ceiling and floor. She just happened to be a client at the same salon and compared notes with the owner each time she was in there getting her hair cut. One thing on which they were both agreed: the activity picked up after the hustle and bustle of the day was over, the vast majority of the building occupants had gone home and just a few die-hards were working past eight o'clock.

Technological tomfoolery came next at the salon. The office PC began to act up. Salon staff complained that the cursor would intermittently whizz around the monitor screen, and yet the mouse would be sitting untouched on its mat.

The paranormal activity within the storage room continued to grow. Rather than just moving around, boxes of hair coloring now began to fly off the shelves.

A tree standing outside the salon had gained the moniker of "the creepy tree," due to its gnarled appearance. Without any apparent cause, the

tree suddenly caught fire one day, requiring the local fire department to respond and extinguish it. The firefighters could offer no cause as to why the tree had combusted.

One night, while taking the trash out to the bins located outside the salon, the owner turned back after dropping the trash bags off and was astonished to spot a female apparition walking into the main entrance doors. The owner described the figure as wearing a cream-colored dress with long, dark hair flowing down her back. As the owner watched incredulously, the ghostly female passed through the salon main doors and seemed to disappear. When she went back inside, the owner found the building to be completely empty.

Developing a strong interest in the phenomena taking place in her salon, the owner was determined to confront the next incident head on. When she was alone in the storage room one night, she began to hear the sound of somebody breathing in the completely empty room. It was, she described to me shortly afterward, "seriously heavy breathing."

Nervous but unwilling to be intimidated on her own property, the owner reached for the camera that she had prepared for just such an occasion and began to take photographs. For the first time since she had purchased it, the camera refused to function properly.

Just days later, one of the stylists saw an apparition. The figure, which was witnessed in the storage room around which so much of the paranormal activity seemed to center, was not seen clearly enough to describe in detail, but it was described by the stylist as having the form of a younger woman, in her late teens or early twenties, wearing clothing that seemed to be long out of style. As quickly as the apparition was there, it was gone again.

A few weeks later, a local sensitive was invited to the salon accompanied by a handful of paranormal investigators (of whom I was one) in order to try to get to the bottom of the ghost stories. Without foreknowledge of the specifics, the sensitive declared that the salon was haunted by not one but two spirits—one of whom had been pregnant when she died.

On hearing this, I was instantly reminded of the pregnant client who fled the salon after witnessing the boxes moving on their own in the storage room and the odd sounds clustered around the entrance. The strange activity had begun a couple hours earlier than usual on that particular night, and the salon owner had very shrewdly wondered about a possible link between the client's pregnancy and the early onset of the ghostly noises.

On this same night, the owner claimed to witness a small, indistinct black blur rush out of the restroom and disappear into the back of a client seated in the salon. The client felt nothing and did not react in the slightest.

The sensitive now reported sensing a male spirit attached to the salon, which she believed may have been a father or uncle to the females she had mentioned earlier. "This man is very, very angry," she intoned solemnly. "He is worried that you might find out the truth about what happened here."

A series of banging noises on the roof drew the paranormal investigators' interest. One investigator named Miranda said that they sounded as though somebody were walking across the roof. After hearing a string of the sounds, two investigators went outside with flashlights to check them out. The roof was completely empty, with no animals or people to be seen up there.

Wandering over to the creepy tree outside the salon, the sensitive declared that the two females had been murdered within eighty feet of it. Subsequent investigation of local news archives uncovered no young female murders in the area. EMF levels by the tree were elevated, doubtless due to the fact that there were high-voltage power lines running directly past and close to the salon. Given the well-documented correlation between high EMF levels and paranormal activity, this might partially explain why this particular salon and its neighboring buildings were experiencing this string of bizarre events. Of course, elevated EMF levels have also been shown to induce mild hallucinations and other sensory abnormalities, so perhaps the root of it all is a mix of haunting and hallucination rolled into one.

Not too long after the investigation was concluded, the salon changed hands. The new owners do not want to discuss the haunting with the public, perhaps out of concern for driving away potential customers. Management of the other businesses in the strip mall take a similar attitude, so it seems that the mystery of this particular female ghost (or should that be ghosts?) and the angry male who accompanies them will not be solved any time soon.

Chapter 8

IF THE SHOE FITS...

BROWN'S SHOE FIT CO.—373 MAIN STREET

Brown's Shoe Fit Company has been putting shoes on the feet of Coloradans since the year 1946, occupying a spacious retail facility near the busy intersection of Third Avenue and Main Street. This thoroughly modern facility, the walls of which are covered with sneakers and running shoes and which is serviced by a courteous and professional staff, seems like an unlikely place to encounter the ghosts and spirits of yesteryear. But the stories attached to this warm and friendly store make for intriguing reading.

The store is run by Jason Wetzel, a friendly but no-nonsense guy who makes no secret of the ghostly occurrences that have taken place in his store.

One of the most commonly accepted truisms among paranormal investigators is that paranormal activity tends to spike—sometimes dramatically—during periods of renovation and remodeling. It is almost as if the structural alterations and redecoration stirs up echoes of the past, disturbing something that has lain mostly dormant until the physical environment started to change.

During a period of remodeling, Jason was in his office one day when he heard a rhythmic thump-thump-thumping noise that seemed to originate from the area of the northwest wall. Puzzled, Jason stepped out of his office and went over to investigate but could find nothing to account for the

strange sounds. Certainly there was nobody in the area at the time, and the sound stopped as quickly as it had begun. Perplexed but thinking little of it, Jason went back to his office and resumed working. The slightly odd incident reappeared in a stranger light when Jason later learned that an employee of the store during the 1940s, a man by the name of Paul Holmes, was well-known for his habit of tossing a knife at the northwest wall and floor, over and over and over again.

On one evening, an off-duty Longmont police officer and his wife happened to be walking along Main Street in a southerly direction, just taking a stroll, when they noticed a woman approaching them from the south. It struck the officer's attention that the lady was wearing a long white dress, which seemed out of place in modern times. In fact, the police officer initially assumed that some kind of historical play was taking place a few blocks over at the Longmont Theatre—so he was taken completely by surprise when the lady in white turned sharply into the doorway of Brown's. The store was closed and locked up, with the foyer and front entrance completely dark.

As the police officer and his wife drew level with the entrance to Brown's, they could hardly believe their eyes. The woman in white had disappeared, but there was nowhere that she could have gone. The shoe store's front door was closed securely, and she had not had time to unlock it with a key and

The front entrance of Brown's Shoe Fit Co., into which a ghostly white lady has been seen to disappear. *Author's collection.*

enter—the doorway had been within their line of sight all along, and there was quite literally nowhere else she could have gone but through the locked front door of Brown's.

The lady in white had vanished into thin air.

This is not the only reported sighting of the lady in white. Other witnesses have seen her actually inside the store itself, standing at one of the counters or in the middle of the store. She appears to be clutching some type of fabric or material in her hands, though nobody has gotten a closer look to determine precisely what it might be.

It is interesting to note that the lady does not appear to be an intelligent apparition, as there are no reports of her making eye contact with witnesses or interacting with them (or her surroundings) in any way. Could this specter be the atmospheric recording of some bygone Longmont resident, perpetually walking this particular stretch of Main Street as she once did during her physical lifetime?

Jason is a member of a 1980s heavy metal rock band that used to practice their music in a room upstairs, directly above the Brown's Shoe Fit store. As manager of the business, Jason was the only person with keys to that room, making it a good choice for a secure storage location in which to keep the band's equipment. They usually just locked their musical instruments in there when they were done playing for the night. Jason had plenty of better things to do than mess with the equipment, so he was quite perplexed when his bandmates complained to him that somebody had gotten in there since their last practice session and changed all of the selector knobs and dials on the equipment. The equipment has also gotten unplugged from the power outlets and, on occasion, even knocked over onto its side—all while the room was securely locked.

The same bandmates were startled during a later practice session when a butter knife fell, coming down from somewhere up in the false ceiling, landing among them with a clatter.

This living area was formerly occupied by a tenant who might best be described as a hoarder; in fact, Jason was forced to clean out a significant amount of junk when he became responsible for the place. The hoarder is said to have abandoned much of his stuff and moved out. There is no record of anybody having died in the room. The building served as a meat market and post office in the past, and another interesting fact to note is that the building adjoining it to the north is the original J.C. Penney store, which was referred to in the chapter covering the Callahan House.

There is an interesting relationship between Jason and the store itself. In the past, whenever Jason would contemplate taking a vacation and

talk about it with his colleagues, the store would be plagued with bizarre electrical mishaps. Computers would start to act up, and lights would burn out with greater frequency. The IT department began to make a running joke of Jason's vacation timings. He now tends to keep quiet about his vacation plans!

Chapter 9
ALL THE WORLD'S A STAGE

THE LONGMONT THEATRE—513 MAIN STREET

Ever since its inception in 1957, the Longmont Theatre Company has had one eye on charity and community service. The group donated profits from its performances to the new Longmont Community Hospital (which is now Longmont United Hospital) to the impressive tune of $1,500.

Originally named the Potpourri Players, the troupe of actors staged their plays at a diverse range of locations throughout the city of Longmont before finally settling down when they found that the Trojan movie house was up for sale by the owner. Located at 513 Main Street in one of the busiest parts of the city, the Trojan was an old movie theater lavishly decorated in the Art Deco style, and the Potpourri Players were fortunately able to afford to purchase it.

The Trojan had seen better days, but the Potpourri Players worked long and hard at renovating the place and converting it from a movie house into a community theater while still retaining much of the original architecture and décor. The citizens of Longmont rallied behind its homegrown troupe of actors, pitching in to support them with volunteer time and cash donations.

A few years after settling into their permanent new home, the Potpourri Players metamorphosed into the Longmont Theatre Company in 1991, a name that it still bears proudly today.

The Longmont Theatre, as seen from across Main Street. *Author's collection.*

There are no documented tragedies or acts of violence associated with this beautiful palace of the arts, but the creaking boards of a theater stage play host to the entire spectrum of human emotion over the years (albeit acted)—love, hate, fear, anger, jealousy, revenge, passion and so many more. It should come as no great surprise to find out that this theater, like so many others around the world, has its ghosts. Over the course of my twenty-year career in ghost hunting, I believe that I have spent time in more haunted theaters than any other type of haunted building. In 2006, I was fortunate enough to investigate the historic Elitch Theater just outside Denver; shortly afterward, my team and I spent a night in Longmont's own Vance Brand Civic Auditorium, about which more can be found elsewhere in this book.

The Longmont Theatre is said to be haunted by a phantom woman in white, dressed in a flowing white gown or robe. She was spotted by a member of the theater company on the night of a full dress rehearsal. The actress who spotted the lady in white looked away for a moment in order to attract the attention of her boyfriend, and when she turned back to indicate the ghostly figure, it had completely disappeared.

What is most fascinating about this apparition is the incredible similarity that it holds to the apparition reported by the off-duty police

The ticket booth of the Longmont Theatre, which is reputedly haunted by the apparition of a woman in white. *Author's collection.*

officer and his wife: a woman in a flowing white dress, seemingly from a different era, so much so that the police officer assumed that she was an actress from a historical play taking place at the Longmont Theatre. The two buildings—Brown's Shoe Fit Co. and the Longmont Theatre—are less than two blocks apart, on the same side of Main Street. Could this mysterious lady in white be the same apparition, flitting between the two buildings on Main Street?

Two members of the theater company were amazed to find that an electronic music synthesizer appeared to be playing random notes without anybody physically touching it. It would be easy to write this off as a piece of faulty equipment, but when the pair checked the keyboard, they were mystified to find that it was not only switched off but also physically unplugged from the main outlet.

"If you were a real ghost," one of them said nervously, "you'd play some Mozart."

As if on cue, several notes immediately sounded in sequence. The pair fled without looking back.

The Longmont Theatre sign, which was once illuminated by unseen hands. *Author's collection.*

Working at the rear of the stage on one occasion, a female member of the theater company yelped when she felt an intensely sharp pain in one of her ankles. Checking her lower leg, she found no evidence of any bites or stings, and nothing had broken the skin or swollen it.

A fairly common experience that has been reported within the Longmont Theatre building is that of props and tools being lifted into the air as if by unseen hands, carried across the stage and then being deposited on the ground.

One night when two members of the Longmont Theatre company were eating dinner just across the street, they both witnessed the big theater marquee sign suddenly illuminate itself. It probably won't surprise you to learn that the building was empty when the sign decided to turn itself on, seemingly of its own volition.

Chapter 10

PARANORMAL PARAMEDICS

The "Ambulance House"—Unidentified Location in Longmont

In every city or small town, you can find that old house. You know the one: the house that kids talk about in excited whispers, running past it nervously on their way home from school, double-daring one another to run across the yard and peek in through the windows of the haunted house on the block.

Some older houses simply look as though they ought to be haunted, victims of nothing more than whispered tales invented by fertile minds, tall tales that grow in the telling, particularly around the month of October, when the leaves fall from the trees and Halloween is on everybody's mind.

And then again, there are some old houses that absolutely deserve their haunted reputation.

I'll refer to this particular property as "the ambulance house," although the emergency medical services crew members who live and work out of there have their own nickname for the house in an area of Longmont that must remain confidential but is located just a stone's throw away from Main Street.

At the time of this writing, the 911 and patient transfer ambulances that serve the City of Longmont are run by a private ambulance company in conjunction with the Longmont Fire Department, and each ambulance is based out of one of the city's six firehouses. But it wasn't always this

way. At least one ambulance operated out of a privately owned home: the ambulance house.

As a relatively new emergency medical technician (EMT), I had been working part time for the private ambulance company for just a couple years when I was first posted to the ambulance house. There were one or two joking (or so I thought) references made to the house ghost by the other EMTs and paramedics but nothing concrete. I spent several years working as an EMT out of that house and can honestly say that I experienced nothing of a paranormal nature at all. Every night that I spent there, I slept peacefully—until the radio blared to life and sent us off to pick up a patient.

Other EMTs were not as lucky as I was. Their sleep was regularly disturbed by a sort of rustling and squishing sound at night, coming from the former bedroom that was now used to store the medical supplies with which we restocked the ambulance after a call. When the storeroom was checked the next day, it turned out that the rustling noise was the sound of saline bags being moved and the squishing being the salt water contained within them. This happened when there was nobody else in the building but the ambulance crew and the house was locked up tight.

The ambulance house was also said to lock itself up every so often. Crews would not always lock the doors during daylight hours and would sometimes find that they had somehow been locked outside of the building when they were heading back from their ambulance after running a call. No keys were left in the locks. Somehow, the lock tumblers had engaged themselves with help from an unseen force.

Lights have been known to turn themselves on and off, seemingly at random, whether the ambulance crew is in residence or not. As they parked the ambulance in the driveway outside the house, more than one EMT or paramedic has been known to say, "I thought we left the lights on…"

The city has changed its private ambulance provider since I last worked out of the ambulance house, but having raised the issue with some of these paramedics and EMTs, I have learned that one thing has most definitely not changed: it would appear that Janice, if that is indeed the resident ghost's name, is still very active at the ambulance house. Some of the EMS crew members who are currently based out of that house have expressed a definite discomfort in one of the bedrooms, which could perhaps be put down to the closet door's habit of opening itself in the middle of the night.

My friend Heather is a former employee of the ambulance company that has taken over residence of the ambulance house. When I reached out to

her in regard to the current situation there, she had some very interesting comments to make.

One day, when Heather had dropped in at the ambulance house in order to check on the crew members, she asked them how they were faring and was told: "We're fine—if we could just sleep." Doors were slamming in the middle of the night. The saline bags continued to rustle. The most common quantity of saline used came in one-thousand-milliliter bags, about the same amount of fluid as three soda cans. Each bag is a respectably hefty weight. The bags are delivered from the manufacturer in boxes of six bags each, which are definitely not very light—each one weighs about as much as a moderately loaded dumbbell. One can easily imagine the surprise felt by the ambulance crew members who went to the bedroom after one particularly restless night in the ambulance house, only to find resistance when they tried to open the door. Their bemusement turned to unease when they saw that a heavy saline box had been wedged against the inside of the store room door, as though someone—or something—did not want to be disturbed inside that room.

When Heather stopped in at the ambulance house on a hot summer afternoon to drop off some supplies to the EMS crews, she was a little perturbed to discover that the temperature in the house—normally very warm during the day, partly due to the less than stellar insulation in the walls and roof—was ice cold. "It was like a complete icebox," she related to me. She had broken out in goose bumps. More ominously, Heather could not shake the distinct feeling that somebody inside that house wanted her out of there and wanted her out of there right away. She hurried to drop off the medical supplies and left straight away.

Heather claims to have actually communicated with the entity that haunts the ambulance house. The ghost is that of a female, she told me, whose name is Janice. The spirit would give no more information than her name. "She hung out a lot in the back part of the house, near the kitchen," the EMT told me.

Lights still switch themselves on and off, as do the faucets. One EMT recently went to sleep with the bedside light turned out and woke up in the middle of the night with the light switched on. Although intermittent, it seems that things are still going bump in the night for Longmont's hardworking emergency medical personnel.

Chapter 11

FIREHOUSE PHANTOMS

LONGMONT FIRE STATION NUMBER ONE—1070 TERRY STREET

For many years, the citizens of Longmont were protected by engine and truck companies based out of five fire stations strategically located across the city. But it soon became apparent that the rapid growth and expansion of twenty-first-century Longmont was stretching the resources of the Fire Department a little thin, and so a sixth station was planned to cover the bustling downtown area. What was once Fire Station One became Station Six, and an eighty-year-old public service building at 1070 Terry Street (facing the sprawling Mountain View cemetery) was subsequently converted into the new Longmont Fire Station One, which opened its doors for service in May 2009.

"Ones," as the firefighters and EMS crew members refer to it, is by far the city's largest station, housing an assistant chief, a fire engine, a ladder truck, an ambulance and a hazardous materials decontamination unit. It is a busy place. Whereas most Longmont fire stations are staffed with four or five responders, Ones has twice that many.

During the modernization and upgrade process, all but two of the original masonry walls and half of the barrel roof were destroyed and replaced. Construction workers added a bay capable of holding six trucks comfortably, twelve dormitories and seven bathrooms.

As a paramedic student still wet behind the ears, I was assigned to Ones during my clinical internship between the years 2009 and 2010. The firefighters and ambulance crews made me most welcome and impressed me with their professionalism and ethic of service to the citizens of Longmont. The station still had that brand-new building smell in the wake of the recent remodel, and so I was surprised to learn from one of the firefighters that Ones had quite the colorful history before the fire department ever came into the picture.

The building was originally constructed in 1938 and served as the Boulder County Highway Department garage. When the United States entered the Second World War, German prisoners of war were shipped to Longmont. City officials ordered that the building be converted into a barracks, resulting in some two hundred POWs being housed there. With vast armies of fighting men deployed overseas and in need of sustenance, it was soon determined that the Germans would be put to useful work in support of the war effort: working on behalf of the Great Western Sugar Company, helping to bring in the sugar beet harvest under the watchful eyes of U.S. Army Military Police officers. Despite the occasional escape and manhunt, the situation was largely peaceful and free of trouble. When the prisoners were repatriated after the war, the building served various storage functions on behalf of the Longmont Department of Public Works until it gained a new lease of life as Fire Station One.

Can the ghosts that sometimes make their presence known to the first responders based at Station One be attributed to the presence of those German prisoners of war, shipped thousands of miles from home to work in a foreign land? Strong emotion—in this case, most likely deep melancholy—has long been suspected as a root cause for cases of ghostly activity. Some of the paranormal activity reported out of Ones appears to be quite benign and harmless, but other instances are decidedly less so.

I have a friend who happens to be a highly skilled paramedic and has served on ambulances within the Longmont 911 system for several years. When I was a guest as Station One during my time as a paramedic student, she was the EMT who served as my partner, and we have remained firm friends ever since. She has risen through the ranks and is by nature a brusque, no-nonsense professional who is not the least bit given to flights of fancy, which makes her a reliable and creditable witness to some truly extraordinary paranormal phenomena in and around Station One.

The dormitories (individual bedrooms) located close to the gymnasium seem to be focal points. More than one firefighter has woken up in the middle of the night suffering from the terrifying feeling of a great weight pushing

down on his or her chest, as though something—or someone—is exerting pressure there and preventing him or her from breathing. The sensation is said to disappear when the recipient wakes up and gets out of bed.

A number of female medics who have slept in those rooms have reported the disconcerting sensation of being watched over while they sleep. They believe that the presence is female (thereby ruling out the "prisoner of war" theory) and is by no means a friendly one, exuding an aura of anger and strong dislike for the occupant of the bedroom. My friend has experienced this personally, and I watched her visibly shudder as she recounted the tale to me. I have been unable to track down any evidence of a death in the building, so why a malevolent female spirit should be attached to these particular rooms at Ones remains a mystery. At any rate, this particular ghost is felt and sensed but never seen.

For reports of an apparition at Ones, we must head over to the large bay in which the fire engines, ladder trucks and ambulance are parked in between calls. At most firehouses (particularly the busier ones, which Station One most certainly is), the firefighters and EMS crew members are usually asleep by 10:00 or 11:00 p.m., snatching some precious rest in between running 911 response calls. When the alarm tones go off in the middle of the night, lights automatically spring to life in each dormitory and an audible alarm sounds. Fuzzy-brained and mumbling, the firefighters and ambulance crew members climb out of bed and head for the vehicle bay. Sometimes (and I speak from fourteen years of experience on the subject) it is possible to actually be dressed in bunker gear and buckled firmly into a seat on the fire engine before actually waking up or being consciously aware of the time spent walking from bed to vehicle.

This particular type of semi-sleepwalking may or may not explain the sightings reported inside Station One's vehicle bay. The vehicle bay is quite gloomy at night, kept this way intentionally to conserve electricity usage. I have been told by a very reliable witness that on more than occasion, the first responder into the bay has seen what appears to be the form of a male firefighter, sitting in the cab of the fire engine and facing forward. The figure disappears almost as soon as it is seen. Could this simply be a trick of the light, easily explainable by the witness being exhausted and jolted rudely into a hypnopompic state (that murky realm of consciousness that lies between sleeping and wakefulness), or is the apparition of a firefighter truly being observed for the briefest of glimpses?

The final account associated with Station One is undoubtedly the most disturbing. The northern-facing bay door looks out directly on

the Mountain View Cemetery, that large garden of stone and grass in which so many of Longmont's citizens have been laid to rest over the years. At around 2:00 a.m., my friend and her paramedic partner (a man with many years of experience dealing with medical emergencies) were returning from a 911 call. After parking the ambulance in the bay and closing the door, the pair sat in silence for a moment, briefly gathering their thoughts before heading off to write the patient care report and then go on to bed.

My friend is not sure who saw it first. Somebody was standing right outside the bay door, visible through the glass. The figure was wearing a dark cloak or cowl that completely obscured its face. It was visible only in profile and appeared to be staring off into the darkness, fixated on something the two medics could not see. They both remained riveted in place, not speaking or moving—in fact, barely breathing. She did not want to make a sound for fear of drawing the creature's attention to herself. "I got the feeling," she told me afterward, "that if we had looked at each other, something really, really bad would have happened."

She doesn't remember how long they both sat there watching this figure, riveted to their seats inside the ambulance. All of a sudden, the cloaked figure turned away from them and began to slowly glide—not walk, but glide—away into the early morning darkness, crossing the road and heading toward Mountain View Cemetery across the street, where it disappeared right before their incredulous eyes.

"Did you see that?" she finally asked. Her partner remained mute for a moment before turning toward her, his face completely aghast with shock. As if on cue, they both blurted out at the same time: "That thing had no effin' legs!"

The two medics started to compare notes. They had both witnessed the mysterious cloaked figure and were adamant that the form appeared to be standing on thin air from the knees down. Whatever it was had seemed to be looking intently at something, and though neither of them ever saw a face, they got a distinct feeling that there were eyes and some kind of face beneath that cowl. The experience chilled them to their very marrow.

But the story does not end there. My friend went to the administration office to write her patient care report, a necessary piece of documentation after every emergency medical call. Her partner headed off to bed, still unnerved by the sighting of what they both believed to be an apparition of some kind but exhausted enough that he needed to sleep before the tones dropped once again.

Soon losing track of time, she was typing away at the computer when her partner suddenly appeared in the doorway again, in an even more disheveled state than before he had gone to bed.

"What the hell happened to you?" my friend asked him. His story chilled her blood.

Lying down and turning out the lights, no sooner had he drifted off into a fitful sleep than he had awoken to the sound of scratching. It seemed to be coming from within the walls, though whether inside or outside of the room it was difficult to be sure. But the sound was like that of nails against masonry or wood.

Chapter 12

THE COFFINS OF SANDSTONE

SANDSTONE RANCH—3001 COLORADO HIGHWAY 119

Despite his deep and ancient English roots, with a lineage traced all the way back to William the Conqueror's invasion of England in 1066, Morse Coffin was the prototypical American pioneer at heart. His great-grandfather fought against the British, serving as a member of the Continental army during the Revolutionary War.

The bulk of the Coffin family settled in the New York region (young Morse was born in Roxbury, Delaware County, in the year 1836), but Morse's parents relocated to Illinois, where they worked the land. Young Morse Coffin learned the harsh realities of the farming and agriculture trade during the warm summer months before transitioning to the schoolroom when the nights drew in close at the year's end. By the time he reached the age of twenty-one, Morse had become a sufficiently accomplished farmer to be entrusted with the running of his father's entire farmstead. This satisfied him for a couple years, but wanderlust soon struck the young man, and he felt the lure of the pioneer life call to him.

On May 5, 1859, the twenty-three year-old Morse Coffin (along with two of his friends) packed up his meager collection of possessions (primarily clothes, a shotgun and forty dollars in cash) into a wagon drawn by three oxen and set out from Illinois, heading west toward the setting sun. This

Morse Coffin, owner of Sandstone Ranch. *Photo courtesy Longmont Museum.*

small caravan of adventurous young men arrived in Boulder, Colorado, a little over two months later on July 18.

Settling in Colorado, Morse secured employment as a sawyer, working on lumber until he had amassed a small financial nest egg—in fact, Morse cut up the wood that was used to construct the first frame house ever constructed in Boulder County. Although he dabbled in prospecting, Morse was less than successful in mining wealth from the ground and soon fell back on his farming skill set. The hardworking and enterprising young man was soon able to afford a 160-acre homestead just outside the burgeoning city of Longmont, which he later expanded by another 200 acres and built a farmstead on it. His brothers, Reuben and George Coffin, soon relocated to the Coffin farm to work it along with him.

By 1865, the farm was burgeoning and becoming quite the local success story. Morse returned to Illinois in order to marry a young lady by the name of Julia Dunbar, and together the two of them returned to Longmont in 1866 and raised five children named Geneva, Adelbert, Merton, Julia Etta and Morse Jr. While Julia took care of the homefront, Morse Sr. served a hitch in the Colorado Third Volunteer Cavalry, putting his riding skills to good use.

Women such as Julia worked incredibly hard, not only birthing, raising and educating their children (and grandchildren) but also taking a hand in daily chores and duties like cooking, cleaning, laundry, yard work and gardening around both the home and the farm. In addition to this laundry list of tasks, Julia and her like believed strongly in taking an active role in community affairs, such as supporting Longmont's various charitable and religious events and institutions. Idleness was almost inconceivable. For

The Coffin home at Sandstone Ranch, circa 1900. *Photo courtesy Longmont Museum.*

example, Julia was a member and fervent supporter of the Women's Relief Corps, an organizational affiliation that caused her to bring the sick and injured into the Coffin household in order to recuperate. According to informational boards posted at the Coffin house today, Julia regularly rose at 3:30 a.m. to make a start on the laundry before starting to cook the first of three waves of breakfast at 6:00 a.m.

Julia Coffin was an extremely forward-thinking woman, and after hearing about the concept of acetylene lighting technology, she diligently investigated the subject and had a groundbreaking system of acetylene lights installed within the homestead before the majority of local citizens had even heard of the idea. The same was true of a revolutionary new concept in gardening: the Coffins were the proud owners of one of Boulder County's first water sprinkler systems. The house's sandstone walls were specifically designed to keep the house interior cool during the heat of the Colorado summer.

Morse died in 1913. Julia survived him by thirteen years, dying in 1926. Both are buried together in Mountain View Cemetery, along with one of their sons.

The Coffin homestead is now owned by the City of Longmont, and the parcel of Coffin family land is known as the Sandstone Ranch Community Park. It can be found by driving east out of Longmont on Highway 119,

heading toward the interstate (I-25). A recreational skate park is the landmark that should tell the inquisitive driver to turn south for a short distance, crest a grassy rise and then find a parking spot next to the original Coffin family house, which serves as a visitor center.

The Sandstone Ranch house was built in 1860, and the sandstone itself from which much of the first floor is constructed was quarried on-site from the ground on which the house still sits. Sandstone Ranch remained in the hands of the Coffin family for the next one hundred years, until it was purchased by the Bigelow family in 1980 and lovingly restored and maintained. It passed into the care of the City of Longmont in the late 1990s and today functions as a wildlife and nature preserve. The place is absolutely beautifully kept, and I highly recommend visiting it whether you are a student of history (aside from the historic house, the original icehouse, toolshed and barn can still be visited) or simply seeking a little peace, quiet and communion with nature.

But what of the Sandstone Ranch ghosts? Perhaps the most intriguing is that of Morse and Julia's daughter, Julia Etta Coffin. There are poorly documented rumors of Julia Etta being allegedly mentally unstable, and she is said to have been confined to an upstairs bedroom and corridor during

The Sandstone Ranch main house, home of the Coffin family. *Author's collection.*

her lifetime. Employees at the Sandstone Ranch house have experienced numerous odd events there. One common occurrence is that when the property manager locks the doors to what was once Julia Etta's bedroom and secures the building for the night, she will arrive the following morning only to find that they have somehow unlocked themselves in the night, and the doors are standing open.

One day, a member of the public who claimed to possess psychic abilities came to visit the house. She was there for barely any time at all before claiming that she could see the spirit of either a girl or a young woman who was desperately unhappy. Could this perhaps be the ghost of Julia Etta Coffin? Certainly many of the staff members believe so.

During September 2013, the city of Longmont (and much of Boulder County) was pounded with torrential rains, which resulted in what is still being referred to by the experts as a "thousand year flood." The devastation was brutal and widespread, taking several lives and causing millions of dollars in property damage. I, therefore, had no hesitation in 2014 when representatives of the city contacted me and asked me if I would be willing to conduct a charity ghost hunt, with members of the public purchasing tickets in order to spend the night investigating the Sandstone Ranch property with myself and my colleagues at the Boulder County Paranormal Research Society, and all profits being donated toward those who had been impacted by the floods. We assembled at Sandstone Ranch on a snowy January night in 2014, eager to investigate the claims of ghostly activity at the Coffin homestead.

It was to be an interesting night, as all such public events usually turn out to be. The interior of the old Coffin house is filled with stuffed birds and beasts, a taxidermist's dream. I got the shock of my life when, on walking into a darkened downstairs room, I flipped on the light switch only to see a bird of prey swooping down on me from the ceiling. I have to be honest and admit that I might have screamed just a little.

As the group assembled together in the main downstairs room for the first time, I was giving my standard "please turn off your cell phones now" spiel when somebody pointed out that several of the lights seemed to be going off and on in the ceiling above us. We stopped to watch, and sure enough, at sporadic intervals a number of the lights were going completely dim and then flaring back into brightness once again. However, despite this encouraging start, we soon tracked the odd lighting activity down to a problematic electrical circuit and wrote this off due to poor wiring.

Settling down to run an EVP experiment in Julia Etta's room, one of our investigators was briefly overcome with an icy chill running down his

spine for no apparent reason. A second investigator (who happened to be sitting directly across from the double doors that are believed to unlock and then open themselves at night) asked any spirits that might be present to announce themselves. He immediately winced, describing a high-pitched buzzing noise that suddenly sounded in his left ear.

Downstairs in the taxidermy room, a third group of investigators was experimenting with an Ovilus device. Becoming increasingly popular in the paranormal research community, the Ovilus and similar products are loaded with a software database vocabulary of (depending on the model) a few hundred or a few thousand words. Each word in that dictionary is assigned to a specific electromagnetic energy level. When those energy levels change in the surrounding air, the Ovilus detects that change and a voice unit speaks the word in question. The somewhat controversial concept behind the Ovilus is that spirits may be able to manipulate electromagnetic levels in the environment surrounding the Ovilus in such a way as to produce meaningful communication.

A noise outside the window drew everybody's attention: a rabbit skittered past, kicking up snow. A fraction of a second beforehand, the Ovilus had piped up: "Rabbit."

A few minutes after that, the group members heard three sharply distinct raps on the wall facing them. Upon investigation, it turned out that nobody was in the room behind that particular wall.

Located in a second-floor room that had a staircase leading up to the attic, an observer saw what he believed to be a dark form crouching at the top of those stairs. Finding nothing tangible when they went to look, the team members deployed a laser grid to cover the staircase. A flicker in the grid suggested that something broke the beams later on during the night, though it is impossible to say precisely what.

Up in what had originally been the master bedroom, a Rem Pod (a device that generates its own magnetic field, which is believed by some to be influenced by ghosts) began to flash, having apparently activated itself. A digital voice recorder was found to be completely drained of power, despite having factory-fresh batteries installed just an hour before.

At 10:30 p.m., the exterior security light that covers the northwest porch flipped itself off, then back on again and off for the second time. The light switch is located inside the main entranceway to the house, had been under observation during the entire incident and no human agency had been spotted anywhere near it. The switch could only be operated manually, and we verified that it wasn't set to any automated sensing or timing device.

Side view of the Sandstone Ranch house, including the haunted upper floor. *Author's collection.*

Investigator Joey Stanford was nonplussed to find that both his digital voice recorder and his flashlight died at exactly the same instant—and even more perplexed when, upon checking both devices, he discovered that the digital voice recorder batteries were fine but that the "hold" button on the recorder had been manually toggled away from the "record" position. The flashlight batteries, on the other hand, were completely drained—despite having been removed from their factory packaging just a few moments before. Another bizarre electrical failure added to the list.

Sadly, most of the EVP experiment recordings were contaminated by noises from our public participants—understandable really, when one considers that they received no training in noise discipline, unlike an experienced paranormal investigator. My colleagues and I left the Coffin house in the cold early morning hours, pondering the events of the evening just gone by and wondering when the Sandstone Ranch house will finally give up its secrets.

Chapter 13

A CLOSE SHAVE

THE ELITE BARBER SHOP—339 MAIN STREET

Like so many of the city's historic buildings, the Elite Barber Shop has a rich and fascinating history, of both the normal and the paranormal variety—which should come as no surprise, given that it is Longmont's oldest barbershop, having served the citizens since 1872.

Taking a step inside the Elite is like taking a step back in time. Once the front door closes on the hustle and bustle of the busy Main Street traffic, you could be entirely forgiven for thinking that somebody has set the clock back fifty years. Orville Christiansen has owned and operated the Elite for the past forty years, ably assisted by his two sons, Jeff and Mike. The family has lovingly maintained the leather upholstered barber chairs, the wooden cabinetry, the mirrors and the many other furnishings. Some of these chairs actually date back to the 1920s, and one wonders just what tales they would tell, if only they could talk.

The Elite is a barbershop of the old school, one of a dying breed. We live in a time in which corporate chain store barbershops and hairdressers seem to be opening up in every strip mall across the country, but the haircuts and beard trims with straight razors performed by Orville and his family are accompanied by the personal touch that is flat-out refreshing, harkening back to a simpler time and small-town America. This approach seems to be

The Elite Barber Shop, circa 1920. *Photo courtesy Longmont Museum.*

working. The store has a dedicated base of loyal clientele, some of whom have been coming back to the Elite to get their hair cut for more than thirty (and in some cases forty) years, some of them being grandfathers who have brought their own sons and grandsons into the fold.

When I visited the Elite Barber Shop in order to research its history, I was struck by a carefully framed barber's certificate that dated back to the late 1870s. Shorty Foster, the recipient of this particular document, was the original occupant of the store at 339 Main. His picture still hangs in a frame inside the store—he is a mustachioed man with a twinkle in his eye, a jolly man of short stature who cut the hair of Longmont men through the last third of the nineteenth century. By all accounts, Shorty loved both Longmont and his barbershop.

Could Shorty Foster be the man who is said to haunt the Elite Barber Shop? Numerous passersby have reported seeing the figure of a man wearing clothes that look to be out of date standing inside the locked and deserted barbershop long after business hours have come to an end. He is said to stare out at them forlornly, sometimes fading away before their eyes. If the haunting is of the intelligent variety, then Shorty's motivation for returning to the shop that he is said to have loved so much during his lifetime would most likely be positive, stemming from his deep affection for the place.

My personal suspicion is that the apparition is not that of Shorty Foster, however. For one thing, the eyewitness reports describe the ghost as being on the taller side. I asked the Christiansen brothers about him, wondering if maybe "Shorty" was an ironic nickname, in the same way that "Little John" was huge in stature, but they were able to confirm for me Shorty was indeed of short stature.

Which begs the question: who is the ghostly man seen by passersby on Main Street? The Elite Barber Shop's staff members have come up with a theory of their own, one that is on the tragic side but seems to fit with the history of the building. If you should visit the Elite sometime, make a point of walking down the length of the shop and taking in the wealth of newspaper articles, barber memorabilia and fine old photographs that are mounted proudly on the left side wall, directly facing the barber chairs and mirrors. This collage provides a fascinating visual chronicle of the Elite Barber Shop's history. Generations of barbers can be seen, cutting the hair of smiling patrons or trimming their beards and moustaches neatly. One such photograph shows a group of three barbers, posing together next to their chairs. The middle of the three men was pointed out to me by Jeff and Mike Christiansen as a former employee who was afflicted with a buzzing or ringing sound in his ears, most likely tinnitus. The affliction is said to have driven him to such great depths of frustration and despair that, one night after closing up and locking the barbershop securely, he went to the room that can still be seen at the back of the store, took out a pistol, sat down and shot himself in the head with it.

This deeply tragic story may be a better explanation for the haunting of the Elite Barber Shop than the idea of Shorty Foster returning to keep an eye on things (although that is certainly a possibility, too). Remembering that the male apparition is said to be quite tall, I scrutinized the framed photograph of the three barbers mounted on the wall. The man in the middle—the man whom the Christiansen brothers told me had committed suicide in the room at the back of the store—is taller than his two companions. Could it be that the spirit of this tormented man has never left his place of work—and his place of death—because of the violent way in which he took his own life?

The reported apparition is not the only ghostly activity that is attached to the Elite Barber Shop. Staff members told me the story of an Elite barber who, quite a few years ago, was on his way home from a long road trip. Realizing that he was starting to feel some fatigue, the man—who happened to be driving along Main Street—sensibly decided to pull over and get some rest for the night rather than push on and risk getting into an accident. Parking up in the lot behind the store, the tired barber let himself into the

The Elite Barber Shop, where the apparition of a tall male figure has been seen through the front window. *Author's collection.*

store and settled down to sleep on a chair in the back room—the same back room that was the scene of his predecessor's suicide.

Drifting off to sleep, it seemed as though he had been out for barely a few minutes before he was awakened by a loud banging sound that seemed to be coming from the main room of the barbershop. Initially writing it off to the usual sounds made by an old building that is settling itself down at night, creaking and contracting as the structure cooled, the barber tried to ignore it and get back to sleep, but the noise intensified.

Frustrated, the barber jumped out of his chair and stalked into the shop itself. Each barber's chair has a wooden cabinet assigned to it in which the barber keeps his combs, razors and other supplies. To his astonishment, one of the cabinet doors was opening and closing itself at will, in an otherwise completely empty shop. The loud, repetitive noise that had awoken him turned out to be the door slamming repeatedly against its frame.

Needless to say, the barber got no further sleep that night and could not wait to get out of there in the morning.

Chapter 14

MR. EDISON, I PRESUME?

THE VANCE BRAND CIVIC AUDITORIUM—600 EAST MOUNTAIN VIEW AVENUE

Born in Longmont in 1931, Vance Brand was an exceptionally gifted child and young man. Excelling in school, at university and as a jet fighter pilot in the United States Marine Corps, Brand went on to take a position as flight engineer for the Lockheed Corporation, putting his extensive knowledge of both aviation and mechanics to good use and eventually attaining the respected role of test pilot.

Vance Brand was therefore exceptionally well placed to apply for the coveted spot as an astronaut when the fledgling National Aeronautics and Space Administration began to hurl rockets up into space. He played several supporting and backup roles in the *Apollo* program and was a frontrunner to be a prime crewmember on *Apollo 18*, but unfortunately, the mission was scrubbed by NASA. He did ultimately make it into space, serving as pilot on the *Apollo-Soyuz* test project. Brand and his fellow astronauts were very nearly killed when they were exposed to toxic levels of nitrogen tetroxide after splashdown, rendering them unconscious and necessitating several weeks in the hospital to recuperate. Proving that you can't keep a good astronaut down, Vance Brand went on to command the space shuttles *Challenger* and *Columbia*. After a long and honorable

The Vance Brand Civic Auditorium, where the author and fellow paranormal investigators heard a loud bang from the middle of an empty stage. *Author's collection.*

career spent in public service, Vance entered a well-deserved retirement in 2008.

Longmont remains justifiably proud of its spacefaring son and displayed that pride by naming both the Vance Brand Airport and the Vance Brand Civic Auditorium after him. Co-located with the Skyline High School at 600 East Mountain View Avenue, the auditorium was built in 1979 and plays host to a variety of cultural events such as theater and orchestral performances. The auditorium seats over 1,300 people and has some incredible acoustics inside.

For some reason, many school theaters tend to attract urban legends and ghost stories. My own school back in my native England had tales of a ghostly girl haunting the place, and supposedly a ghostly black dog would appear out of thin air if a terrified student should sit in a specific seat. It is interesting to note that a similar urban legend regarding a black dog (an animal that is so often associated with death and the supernatural throughout history) has also been told in regards to the Vance Brand Civic Auditorium.

It has also been claimed numerous times that during the building of the auditorium, one of the construction workers (or possibly a janitor, depending on which version of the story you hear) fell from some scaffolding and was killed—something for which I have been unable to track down any evidence

at all. Certainly, when I spoke with the auditorium staff, they denied the dead construction worker story outright and had the same response about the shaggy black dog tale.

When I interviewed the auditorium manager and some of the staff back in May 2008, they were only too happy to relate to me the types of paranormal phenomena that have been reported in the auditorium over the previous thirty years. The technical supervisor told me that there have been numerous reports of footsteps being heard in the auditorium and the surrounding corridors over the years, usually at night when the building is empty and the doors are locked. "Members of staff often chase after the footsteps, to make sure that there's not an intruder in the building," he told me calmly. "But there's never anybody to be found."

Cabling and curtains have been seen to move, seemingly of their own volition, and there is also said to be a great deal of thuds, bangs and crashes reported around the facility on a fairly regular basis. Once again, no culprit is ever found when employees go in search of the source of the noises. This was something that I would soon experience for myself.

Cold spots have also been reported by the students and patrons, but perhaps the most common type of phenomena is electrical in nature: problematic behavior with the wiring, leading to lights flashing on and off at irregular intervals. Electrical equipment is also known to behave erratically, such as the volume going up and down through the speaker system. All of this has led to the resident spook being given the somewhat tongue-in-cheek nickname of "Edison," after the late inventor Thomas Edison, that great pioneer of all things electrical.

In a 2005 article titled "Students Search for Signs of Specter" written for the *Longmont Times-Call*, journalist Paula Aven Gladych documents what seems to be the first serious investigation of the Vance Brand Civic Auditorium by a couple students from the parapsychology program at the University of Colorado–Boulder. Although the auditorium staff members told me that there had been no reports of actual apparitions seen in the theater, the article states that a student once reported seeing "a ghostly figure watching from the back of the balcony." This would presumably be the same balcony that collapsed during the construction of the auditorium, but just like the auditorium employees, facilities manager John Benton is quoted as saying that despite the stories regarding the death of an employee during the collapse, nobody, in fact, died during the construction of the auditorium.

This tracks with the testimony offered by one of the two investigating students, a young man by the name of Jonathan Tsengouras, who spent

several years at band practice inside the Vance Brand Civic Auditorium and claims to have "seen ghostly figures and heard strange noises."

During the course of their investigation, student investigator Rachel Nielsen felt goose bumps and claimed to have seen the "the head and torso of a man standing beside a large American flag, which graced the stage for one of the school's theater productions." The two intrepid investigators recorded video footage and took a multitude of still photographs but seemed to have drawn a blank at the end of the investigation. The male apparition that Jonathan Tsengouras believed he had sighted on the stage seemed to have been a little camera-shy.

The article goes on to relate an exchange between the students and auditorium facility manager John Benton in which they ask him to provide some rational explanation for the accounts of ghostly activity over the course of the building's lifetime. After all, Mr. Benton had worked at the auditorium for almost twenty years at the time of the interview—who better to keep his finger on the pulse of the strange goings-on in there?

His answers are very well thought-out and make a great deal of sense. Mr. Benton has obviously given some serious consideration to the possibility of the auditorium being haunted. He has left video camera equipment recording the stage overnight and has even gone so far as to stay in the building alone overnight in a bid to get to the bottom of the reported hauntings. Mr. Benton attributes the fluctuating lighting levels to the fact that they were hooked into an old analog control board, which was prone to power spikes and brownouts that dimmed and brightened the lights at random. Now that this board has been replaced with a newer digital version, the lights appear to be behaving themselves. As for the noises and movement of cabling and curtains, the skeptical facilities manager offers a far more prosaic explanation: the heating, ventilation and air conditioning (HVAC) system is generating air flow that causes them to be influenced by the artificial breeze.

Insofar as it goes, these are reasonable explanations. But they do fail to explain the repeated sounds of footsteps, the loud bangs coming from the stage area and the apparition seen in the balcony area. Which is why, on a warm May evening in 2008, I rented the auditorium for the night and had myself and my team locked inside (with an employee chaperone) in an attempt to find out the truth for ourselves.

From a purely technical sense, everything was baselined as normal—no electromagnetic field spikes, no unusually cold or warm spots and even background radiation and air ionization levels were normal. Considering

that so much of the reportedly paranormal activity seemed to center around the stage and its surrounding environs, we strategically placed video camcorders to cover it as thoroughly as possible.

At 11:15 p.m., a deafeningly loud crash occurred from somewhere in the backstage area. I would describe it as the sound that a large piece of furniture, such as a wardrobe, would make if you tipped it over on a wooden floor. The boom took everybody aback for a moment, but we recovered very quickly. I happened to be standing on the stage at the time, along with my fellow investigator Kira. We felt no tremor beneath our feet, which one would expect if something had fallen onto the ground just a few feet away from us. While the rest of the observers descended on the stage from their positions throughout the auditorium, Kira and I immediately pushed backstage through the heavy curtain. Nothing was out of place, and certainly no heavy object had fallen in order to account for the loud crash of something hitting the stage floor.

Our designated chaperone for the evening was a member of the technical staff and the only person not directly within our line of sight during the incident. We found him sitting in the staff office, kicking back with his feet up watching the TV at a low volume. When asked about the crashing sound, he denied having heard a thing. Judging from the position of the staff office in relation to the stage, there's no conceivable way that he could have made the noise himself and then hightailed it back to his office, all without being seen or heard by any of our investigators—and even if that were possible, what motive would he have had to do so? Nor could he have thrown an object to create the noise because nothing was out of place when we checked the backstage area carefully and compared the positions of all props and furnishings to their positions as recorded during our baseline sweeps earlier in the evening.

Half an hour passed without further incident. As the clock ticked its way toward midnight, our team regrouped in the front row of seats (because why pass up comfortable seating?) and discussed the crashing incident in hushed, excited tones. We would later find out upon playing back the video recording from the locked off cameras that nothing moved on the stage when the loud noise occurred, and neither did the curtains move. A heavy object falling would be expected to generate some sort of draft, not to mention a vibration on the raised stage floor.

As we debated these points and more, quietly arguing back and forth, the conversation was suddenly stopped dead in its tracks as what sounded like several distinct footsteps seemed to move directly across the completely

empty stage right in front of us. One. Two. Three. Four. Five: five regularly spaced creaks. Listening to the audio playback, it sounds exactly like the measured tread of a fairly sizeable adult, striding slowly but with great deliberation for five steps across the stage, before suddenly disappearing at stage center.

Is it possible that these creaks were simply the contractions of wood settling down at night? Possible, yes, but I think this is an unlikely explanation. For one thing, no similar creaks occurred earlier that evening, and none occurred later that night and into the following morning either. Whatever this was, it was a completely isolated event. The air conditioning had not just kicked in, nor was there noticeable air movement or vibration on the stage (one of the benefits of having video footage to review after the fact). Were we witnessing what so many others had reported from within the auditorium over the years—the phantom footsteps of a spook nicknamed Edison, making his presence known for a brief instant before disappearing into the background once more?

While Mr. Benton remains skeptical, there are still plenty who believe that there is more going on at the Vance Brand Civic Auditorium than meets the eye.

Chapter 15

A SENSE OF INCENSE

THE OLD ST. STEPHEN'S CHURCH—470 MAIN STREET

One of the most picturesque old buildings to be found in the city of Longmont, this beautiful brick church started life as an Episcopalian place of worship back in 1882. According to the website of the St. Vrain Historical Society, the building was painted white in 1915 and thereafter became a Longmont Main Street fixture, going by the informal name of the "Little White Church." The structure was added to over the years, growing in order to keep pace with an increasingly large congregation, until reaching capacity and causing the Episcopalian church to relocate to more spacious quarters (it is now located across from Kanemoto Park in the Southmoor Park area of Longmont).

Fortunately for the "Little White Church," the St. Vrain Historical Society came to the rescue in 1976, purchasing the building and working diligently to restore it to its former glory. It is no longer painted white, having long since been returned to its natural brick color, but in all other respects, the church looks like a nineteenth-century house of worship. The business affairs of the St. Vrain Historical Society are now run out of the church, which is open and accessible to the public on most weekdays.

In *Northern Colorado Ghost Stories*, author Nancy Hansford writes of a visit paid to the church by Gail and Eric Jones (currently with the team

The old St. Stephen's church, where the smell of incense has been reported by paranormal investigators who were staking out the place. *Author's collection.*

Spirit Connection Investigations) and sensitive Dori Spence. As mentioned elsewhere in this book, the insights of those who claim to be either "psychic" or "sensitive" do not, in and of themselves, constitute evidence.

A side view of the old St. Stephen's Church. *Author's collection.*

They must be backed up with other types of findings if we are to consider them to be valid.

According to Nancy Hansford's book, Dori Spence stated that the area surrounding the altar and the eastern part of the church was the most active with spiritual energy. Without telling him this, she requested that investigator Eric Jones step over toward the altar for a moment and report any odd sensations or feelings that he might have over there.

"The altar of that church smelled strongly of incense," Eric told me in a 2015 interview. "And then, all of a sudden, the smell was gone. Just like that, it disappeared." Olfactory phenomena (essentially, that of "phantom smells") is common throughout the literature of paranormal research, so Eric's claim is not at all difficult to believe.

Nancy Hansford also relates the story of artist Barbara Stone, one-time resident of Old St. Stephen's Church, who told Dori that one day when she took her camera out of the bag, it went off accidentally, taking a picture through the pocket of the bag. The film captured the image of a child's pinafore.

Dori also saw a ghostly clothesline extended across the windows on the east side. On it, there was a shadowy deacon's coat hanging upside down and next to it was one child's pinafore. They were hung there to dry in front of the open window.

The author also goes on to say that the apparition of the former priest was spotted walking around outside the church.

Chapter 16

CALL ME, MAYBE

THE HANSEN BUILDING—477 MAIN STREET

Standing at the intersection of Main Street and Fifth Avenue, the historic Hansen Building is a beautiful, rust-colored brick building that not only has a fascinating history but has also played a crucial role in the expansion of Longmont. It was constructed in 1905 by the Colorado Telephone Company for the express purpose of being Longmont's central telephone exchange. It housed not only all of the wiring and fledgling telephone wiring, call-switching and exchange equipment but also the operators who routed and placed thousands of calls on a daily basis.

The exchange didn't actually go live until a year later, in early 1906. According to the excellent Longmontian blog, over eight hundred circuits were serviced by five human operators, all of whom usually worked in four-hour shifts (although at maximum capacity, eight operators could be accommodated) and even had a comfortable room set aside on site for downtime and relaxation.

This new building heralded a much welcomed dramatic upswing in the quality of telephony available to the citizens of Longmont, a newly burgeoning city whose rapid expansion was far outpacing expectation and municipal planning. Ownership has changed hands many times over the years, and the building has played a diverse number of roles since its

The historic Hansen building, in which old-style analog telephones are said to ring after hours. *Author's collection.*

inception as a telephony hub: an insurance agency, a beauty salon, an osteopathic practice, a vinyl record and cassette store and even an antique shop. At the time of this writing (March 2015), it is home to the La Vita Bella coffeehouse, a warm, welcoming place for Longmonters to grab a cup of joe and a snack.

So why is it still referred to as the "Hansen Building" rather than the "old phone exchange" or something similar? The people of Longmont owe a debt of gratitude to attorneys Sandy and Jim Hansen, who operated their law firm out of the building during the 1990s and who developed a deep fondness for the old building at Fifth and Main. Over the course of two years, the Hansens sank almost $1 million of their own money into the process of lovingly refurbishing, restoring and renovating the building to the condition in which you can still find it today—a place where locally quarried stone and beautifully crafted woods predominate.

A 2003 *Fort Collins Coloradoan* article describes paranormal activity in the Hansen Building, which was at the time home to a mortgage company. The

A rear view of the Hansen Building, now a coffee shop. *Author's collection.*

article states, "'We always think we hear the phone ringing, even when it's not,' said Gail Calabrese, at Capital Advantage Mortgage in Longmont.

'It's the one thing everyone here has noticed. We always think it's eerie. We hear ringing, and we look at the phone, but nothing's lighting up.'"

Although I have heard of no apparitions being seen on the premises, this story of phones ringing is one that has been reported by numerous tenants of the Hansen Building over the past few decades. Perhaps the most fascinating aspect of this particular "recording type haunting" is that the noise of the telephones is in the "ringing bells" style of the old generation of phones, not the strident bleeping of a more modern model. In the paranormal research community, an explanation for such ghostly phenomena known as the stone tape theory has long been commonly accepted. Simply put, the theory goes that certain types of rock or stone may have the extraordinary property of being able to record events as they occur (whether they be sights, sounds or smells) and then "replay" them back at a later time, whenever a susceptible witness is present to receive

them. This is much like using a tape recorder to capture a conversation on magnetic ferrous tape and then play it back late using an electrically powered mechanism.

Could it be that the modern-day tenants of the Hansen Building are inadvertently replaying the sounds of the city's original telephone exchange, as the busy operators went about their daily business to the accompaniment of ringing telephones?

Chapter 17

OF HUNCHBACKS AND HAUNTINGS

THE CITY OF LONGMONT PRINT SHOP AND DEVELOPMENT SERVICES CENTER—385 KIMBARK STREET

Meeting the printing needs of a city the size of Longmont is a full-time job, which is why the city has its own dedicated print shop. But the single-story building once played a very different role: it was originally a mortuary, owned and occupied by the firm of Milo G. Rice Undertaking, where the local morticians plied their trade and stored the bodies of Longmont's dead.

When I toured the building prior to conducting one of several overnight paranormal investigations, this point was made very clear to me when I was led down into the basement. "This is where the original body chute dumped into here from up above," one of the printers told me, pointing toward a body-sized hole in the basement wall that had long since been concreted over. Heading back upstairs and walking around the building exterior, I stopped and squatted in the side alleyway that separates this building from its neighbor. The entrance to the body chute can still be seen from the alleyway, and it takes little imagination to conjure up the image of the morticians' assistants of yesteryear lifting the dead body of their latest client and maneuvering it down into the chute, allowing it to slide on down into the cooler body storage area in the basement, where embalming would

Fourth Avenue in winter, early 1900s. The current city print shop is seen in its earlier incarnation as Milo G. Rice Undertaking. *Photo courtesy Longmont Museum.*

The cemented-over entrance to the old body chute, located in the side wall of the city print shop, originally a mortuary. *Author's collection.*

The print shop as seen in March 2015. *Author's collection.*

also take place. One hopes that they were gentle and dignified when going about this somber task.

My team and I first investigated the print shop in 2009, when staff reported bizarre and unexplained noises such as banging that sounded as if it originated from the basement, sometimes accompanied by flashes of bright light down there. Sometimes an indistinct hubbub was heard, as though two or more people were talking conspiratorially in low voices. When members of the staff would go down to the basement to investigate, it was always cold, empty and dark.

We were locked into the print shop overnight and were able to cover pretty much every nook and cranny with the number of personnel available. Unfortunately, our investigation turned out to be rather uneventful and disappointing. No paranormal activity manifested itself, and all of our EVP sessions turned up nothing. It was a tired and somewhat disheartened team of ghost hunters who made their way back home to bed when the sun came up. As the Boulder County Paranormal Research Society director, I considered myself fortunate to have had the opportunity extended to me to investigate such a cool and historic old location but chalked up the stories of hauntings to "maybe, maybe not," and mentally filed the case away for the next three years. I didn't give the ghost stories another thought.

And then, shortly before Halloween 2013, my interest was well and truly piqued by an e-mail that popped up in my inbox one morning. I was being contacted by an employee of the city on behalf of one of the members of the cleaning staff who works regularly at the print shop. It seemed that paranormal activity had picked up in the three years since my last visit.

But first, a quick word about the way in which the building is laid out. The print shop is situated directly next door to the City of Longmont Development Services Center, a much larger administrative building that houses quite a few employees and civil servants. Both buildings are considered to be part of the same complex and are not only physically connected but also share a common courtyard, which is secured from the outside world by a large lockable gate during off-duty hours.

Based on the e-mail, I learned that the same members of the cleaning staff are responsible for taking care of both the print shop and the Development Services Center, usually one after the other. They tend to arrive very early in the morning, usually when it is still dark outside and there is very little traffic on the roads. On a dark morning at around five o'clock, one of the cleaning staff was hard at work inside the Development Services Center, thoroughly cleaning the master staircase and getting things shipshape for the business day ahead. Happening to glance up and out of the window, she looked across the shared courtyard in the general direction of the print shop.

What she saw there chilled her blood.

The figure of a sixty-year-old hunchbacked woman was staring right back at her from one of the print shop windows. The pair locked eyes, and the woman smiled back at the cleaner.

When I interviewed the cleaning lady in person, she told me with a nervous laugh that she had then turned slowly back around, in an emotional state somewhat akin to frightened denial, and "I was hoping that I was just going crazy, but when I turned back around, she was shuffling off with her little hunched back, and then disappeared before my eyes!"

The city staff asked me if the Boulder County Paranormal Research Society would like to return to the print shop and the Development Services Center in order to conduct a second investigation. My immediate thought was: a hunchbacked apparition? Would we EVER!

Which is how we found ourselves heading back to the two city buildings on a cold Friday evening, ready to tackle the mystery of the ghostly hunchback. A good paranormal investigator always looks for a rational, non-paranormal explanation first before leaping to a paranormal one. Upon questioning the staff carefully, I learned that there is a trash dumpster behind the print shop that

The city print shop, originally a mortuary. *Author's collection.*

is often used by some of Longmont's homeless population to sleep in on cold nights, burrowing down into the trash in order to try to stay warm. Could it be possible that what the cleaning lady had actually seen was a transient, surfacing from the dumpster just before sunrise? It was, after all, a bitterly cold night when the figure had been seen. There was even a blanket of snow on the ground.

But the cleaning lady immediately dismissed that possibility. The hunchbacked lady that she had seen had been inside the print shop, which had been closed, locked and even alarmed at the time; she knew this because she had gone and checked on the security features of the print shop once the sun came up. There was no evidence of tampering on any of the print shop's doors or windows, no alarm had been triggered indicating that a forced entry might have taken place and the dusting of snow that had fallen the night before around the entrances to the print shop was completely undisturbed. There were also no footsteps leading to or from the dumpster.

The apparition wasn't the only bizarre activity that had taken place within the two adjacent buildings. Odd mechanical and electrical occurrences had been cropping up with increasing regularity. One morning, the cleaner was annoyed to find that four light switches were inoperative. She flipped

The Development Services Center. Staff members report seeing the apparition of a grinning, hunchbacked old woman. *Author's collection.*

them between the off and on positions multiple times, just to be sure that the attached lights were truly dead. Frustrated, she called in a member of the maintenance staff. When he arrived and flipped the switches to see for himself, the maintenance guy was bemused to see that the lights turned on and off again the very first time he tried them.

Of more concern to me was an event that suggested that the haunting of the print shop may not have been entirely benevolent in nature. There are a series of large, conical metal vent covers hanging from the ceiling inside the print shop. Walking beneath one of them one morning, the cleaning lady was struck on the head by what turned out to be a falling vent cover. I inspected the unit myself and found it was fitted snugly and securely in place and would have required a fairly firm tug in order to remove it from its mount. After speaking with the print staff, I confirmed that the vent cover had not fallen from its mount either prior to or after the incident with the cleaner, which had been witnessed by a member of the print staff.

The cleaning lady and a colleague of hers from the neighboring building both told me that they believed the spirit of the hunchbacked woman was

responsible for the haunting of the print shop and its neighboring Development Services Center but that she did not mean anybody harm—she was simply a mischievous earthbound soul who wanted to have a little fun and perhaps draw some attention to her presence.

I talked with a pair of long-term male print shop employees, two very down-to-earth, blue-collar guys who told me in a completely matter-of-fact way that for more years than they could remember, the print shop doorbell was known to ring of its own accord. Nobody was ever seen to be standing there pushing it. I was equally surprised to learn that the same doorbell shenanigans were taking place at the Development Services Center next door, which had its doorbell wired to an entirely different circuit.

As more and more fascinating information came to light, my fellow investigators and I took a guided tour of the neighboring Development Services Center. This is a much bigger building than the print shop, as you can see from the photographs in this book, laid out on multiple floors and possessing a spacious basement. We were shown upstairs to a janitor's closet, where tools and cleaning equipment of various types are stored. Glancing around warily as she spoke, the cleaning lady related how a shovel had recently flown away from its storage rack before her very eyes. My teammates tried to replicate the phenomenon, but to no avail. The shovel was held securely in place, requiring a definite, deliberate effort to pull it away from the wall.

We were shown a powered floor cleaning machine, one of those lawnmower-like push-along devices with rotating circular brushes underneath. One morning, when the rest of the building was completely empty, the cleaning machine powered itself up of its own accord.

An employee who works in the Development Services Center told me of the morning that she happened to be mopping the tiles in the lobby when the elevator pinged to indicate its arrival on the ground floor. Puzzled, she went over to see who was taking an elevator when the building was supposedly empty. The call button was lit up, as though somebody had pushed it manually, but when the doors opened, the elevator was completely empty. This bizarre happening repeated itself twice more that same day, and when the elevator was subsequently inspected during its scheduled maintenance check, no faults were found with it whatsoever.

Intrigued, I asked to be shown the basement. Amongst other things, a lot of the Development Services Center's information technology equipment is installed down there. At around seven o'clock one evening, a computer network engineer was working away at some of the IT equipment down in the basement, when he heard the sound of music coming from elsewhere

The original City Hall, now functioning as the Longmont Development Services Center. The lobby doorbell is known to ring itself. *Author's collection.*

in the building, followed almost immediately by the noise of a hushed conversation. I was reminded straight away of the hushed voices reported from the basement of the print shop. Realizing that he was the only person locked in the building that night, the network engineer hurriedly finished up his task and left the building as quickly as possible, never looking back over his shoulder. He now flatly refuses to go back to the Development Services Center after the sun has gone down.

In a very similar vein, two teenaged girls who were performing community service in the same basement suddenly fled upstairs and refused to go back down there again. They had heard voices speaking down in the basement, they claimed, but they knew that nobody else was working down there at the time. Nobody had told them about the ghostly stories associated with the building.

With the sheer amount of activity associated with the basements of both buildings, I kept thinking back to the print shop's prior history as a mortuary and wondered exactly how many corpses were prepared and embalmed down in that basement during the nineteenth century. Could there be a connection with the paranormal episodes being reported today?

It's worth noting that electromagnetic field levels were on the higher side of the normal range, particularly along the western wall of the print shop (the area in which the female apparition was reportedly seen). Elevated EMF

levels have been noted to have some unusual effects on the human brain, such as inducing hallucinations. But the area in which the cleaning lady was standing when she witnessed the apparent ghost registered entirely normal levels of electromagnetic energy. With that being said, another theory that is rapidly gaining traction within the paranormal research community is the possibility that higher levels of EMF may actually serve as a kind of catalyst or fuel, triggering the manifestation of various types of paranormal activity. The jury is still out on this one, but it is a truly fascinating concept.

My team was able to explain one seemingly paranormal happening: the complaint that some employees had made of a lobby alarm (the sort of chime that shops have installed in order to warn the staff when a customer enters the store) sounding when nobody else was there. Experimenting carefully, BCPRS investigators Seth Woodmansee and Joey Stanford determined that the activity of somebody mopping the tiles at the extreme range of the sensor's reach would set off the chimes. The alarm sensor was calibrated to a level that was slightly oversensitive, so the motion of somebody moving past the sensor's periphery would trigger a false alarm. So there was one ghostly claim that was thoroughly debunked, but what about all the others?

Small clusters of my paranormal investigators rotated throughout both the Development Services Center and the print shop throughout the night, taking a series of temperature and EMF readings and also conducting multiple electronic voice phenomena recording sessions. Hundreds of photographs were taken, and hours of video footage were recorded, focusing on the areas in which the reports of paranormal activity seemed to be concentrated.

Yet again, the overnight lockdown investigation was a bust. None of our control objects were moved, and nothing paranormal showed up on any of our recording devices. Shortly before daybreak, we were joined once again by the cleaning lady who had witnessed the apparition of the hunchbacked old lady. She told me that she was quite frankly frightened of being in the print shop and Development Services Center when she was alone in the morning and that the thought of being watched by the phantom lady was interfering with her ability to do her work.

I sympathized completely, and then an idea struck me. I recalled having read an article about the haunting of the White House. Supposedly, a member of the Secret Service who was assigned to the presidential close protection detail encountered the apparition of Abraham Lincoln, a not uncommon occurrence in the White House if the paranormal case literature is to be believed. Although the agents of the United States Secret Service are not known for being timid or nervous, this particular agent was at the end

of his rope. Standing in the Lincoln Bedroom one day, having made sure that there was nobody within sight or earshot, he is said to have made a plea to the ghost of the former president: "Mr. President, sir, you're frightening me to within an inch of my life, and it's affecting my ability to protect the president. Please, sir, knock it off already!" The paranormal activity inside the White House is then supposed to have been reduced dramatically.

Gathering my entire crew and the city employees all together, I cleared my throat and then delivered what I hope was a stern (but respectful) lecture to the phantom lady. I pointed out that she was welcome to hang out at the print shop and its neighboring building if that was what she wanted, but that she was, under no circumstances, to show her form, as it would serve only to frighten the staff working there and interfere with their ability to do the job they were being paid to do. There were to be no more electrical or mechanical shenanigans, no ringing the doorbells or fooling around with the cleaning equipment. The people who worked on behalf of the people of Longmont were to be left to do their jobs in peace…or else! (I had no actual "or else" card to play, so I just bluffed and hoped for the best.)

The cleaning lady said that she felt reassured, and feeling that my team had done all that it reasonably could on that particular night, we packed up our kit and headed home to bed.

One month later, I received a follow-up e-mail from her.

> *Richard,*
>
> *I was very shocked that you guys did not find anything here. I was hoping that it would show up. For my part, I know she is still here because I saw her again and I still feel her presence around the building.*
>
> *Now what has been happening around the building? I still have lights that won't turn on in the morning, and switches have been checked and new ones put in. Guess what? Still the same problem—they turn on only when they want to. The doorbell in the lobby is still going off. The alarm company has been out and replaced the mother board for the second time.*

Sighing at the fact that my entreaty had patently not worked, I wrote back to her and asked if she wanted me to put her in touch with a pastor or other spiritual specialist who could perform a ritual of cleansing on the building. Surprisingly, she demurred, on the grounds that she hoped that the ghostly old hunchback would move on when she was good and ready to do so.

Chapter 18

A Tale of Two Libraries

Longmont Channel 8 Public Access Cable TV (the Old Carnegie Library)—457 Fourth Avenue/The Longmont Public Library—409 Fourth Avenue

Mention the phrase "Longmont library," and the image conjured up in the mind of most listeners would be that of the huge modern public lending library that has supplied the needs and desires of Longmont readers since the year 1993. But few people know that Longmont has had more than one library—in fact, it has had several, although only two fall within the scope of this book.

The old Carnegie Library stands directly next to the new library. It is a much smaller structure, whose successor sibling towers above it, and the genesis of this elder library springs from the generosity of millionaire philanthropist Andrew Carnegie (he of Carnegie Hall fame). There was a time when over two thousand Carnegie-funded libraries dotted the towns and cities across the United States; Carnegie was a strong proponent of public literacy and education and did not shy away from backing his position with cash. A slew of grants issued in his name resulted in libraries springing up far and wide.

It was in the year 1913 that the first books were checked out of the Carnegie Library, which served the city faithfully for almost sixty years, before being replaced by a completely new structure in 1972. The old library is today the home of Longmont's public access cable television

The old Carnegie Library, now a cable TV recording studio. Former staff members were grabbed by unseen hands in the basement. *Author's collection.*

organization, and when I interviewed Gail and Eric Jones of the Spirit Connection Investigations team, they related a ghost story told to them by a friend who works in television production there. Some employees dreaded going down into the basement, the story goes, because in the gloom at the bottom of the staircase they were grabbed by a strong hand—when nobody else was in the building.

A larger replacement library building was constructed, but after just over twenty years, city officials demolished it and replaced it with the modern two-story structure that stands there today, shoulder to shoulder with the old Carnegie building. Although one might not expect such a modern building to be haunted, it's important to remember that often it is the ground or area on which the building is built, and not necessarily the bricks and mortar themselves, that give rise to a particular haunting.

With that being said, the reasons behind the paranormal activity that is reported at the modern library remain something of a mystery. I spoke with a city employee who had an encounter with the ghost during her time at the library. She sent me an e-mail describing the experience in her own words:

The public library, where an encounter with the resident ghost is regarded as an initiation to the job for some new staff members. *Author's collection.*

I had an experience at the library my first week on the job, March 2013. I was "welcomed" by the "library ghost," according to another co-worker at the time. My experience involved a book that "jumped" off the shelf at me. The book shelf is located behind the Information desk at the library, on the north wall, under the wall-mounted quilt.

My co-worker at the time told me the book slid toward the edge of the shelf and off, flew up at an angle, hitting me in the shoulder. It was at this time she said I had been welcomed by the library ghost. I placed that book back on the shelf, every which way, against the back of the shelf, partially hanging off the edge, and it did not "jump," or fall, off the shelf when I walked by. It didn't even budge.

Intrigued, I went on to ask her what her colleagues at the library felt about the possibility of it being haunted. Did the majority of them believe it, or did they tend to write events such as this off with a shrug?

I think staff is equally divided, non-believers and believers…The several I spoke with have had those eerie feelings, like being watched, or hearing noises when they're there alone…It's a big library, especially when you're alone, and it's an older building…things creak. I did search the library once, at close, thinking someone was still in the building. I about called the police department, to have them sweep the building…I didn't ever find anyone, but it sure sounded like someone was rustling around in the stacks.

Shortly after this, an investigation conducted at the library by members of the Boulder County Paranormal Research Society documented similarly odd noises. Although they were not able to figure out the cause, after a lengthy period of experimentation, those present concluded that the strange sounds could not be put down to drafts and air flow throughout the building. The noises were too heavy, and no books were found to be out of place when the rows of shelving were checked.

During my research, I have been unable to turn up any reasons why either building should be haunted. I could find no record of tragedy or violence attached to either one of the two libraries. Could it be that a playful former librarian is not yet ready to give up in death the libraries that he or she was so fond of in life?

Chapter 19

VOICES FROM NOWHERE

THE CITY COUNCIL CHAMBERS, 350 KIMBARK STREET

Resembling nothing so much as an indoor mall, this sprawling building complex sandwiched between Kimbark and Emery Streets is where much of the city's daily administrative business takes place. Whether you happen to be paying a utility bill, applying for a city job or even sitting on the mayor's governing council, one of the first things that you will notice about this place is how busy and bustling it is during the daylight hours.

When office hours are over and the city offices close up their shutters for the evening, the complex is a calm and peaceful place, hardly the scene that one would imagine for any sort of ghost story.

The main council chamber is a large round room, with auditorium seating that surrounds the desks at which the mayor and his or her colleagues conduct the business of the city. It is a very high-tech facility, outfitted with high-definition video monitors and computer equipment. But a number of employees have complained of feeling disconcerted while working in that room after dark, a vaguely indefinable sense of discomfort that nonetheless means that some of them do not like to be in the council chamber alone.

Electrical equipment also behaves oddly in the room, sometimes powering itself on and off with no apparent cause. Of course, this could simply be a case of malfunctioning equipment rather than anything paranormal. But

when I was invited to spend the night in the council chambers in order to investigate, I didn't hesitate for even a second. Accompanied by my fellow investigators from the Boulder County Paranormal Research Society and guests from Spirit Connection Investigations, city employees locked us inside the building on a warm Saturday evening in March.

Our first order of business was to investigate the main auditorium. High and variable levels of electromagnetic energy fluctuated around the chamber, due, I suspect, to the large amount of audiovisual and computer equipment installed there. The elevated EMF spots may well explain the uneasy feelings experienced by those who work within the building.

While sitting in the room conducting electronic voice phenomena experiments, two investigators experienced the same uncanny sensation of being touched lightly on the neck, as though being brushed by a fingertip, and then the hair standing up on the back of their necks as though being played with by an unseen hand.

Investigators did their best to find a rational explanation, testing airflow within the chamber using strips of hanging paper to visualize the currents. The female observers who reported the odd sensation are not known for being fanciful (indeed, one is a PhD with a highly analytical outlook) and experienced the sensation after I asked them to change seats, moving down to the left. The sensation occurred in different seats, and indeed in different seating sections of the chamber, always on the right-hand side of their necks. Despite this being a subjective experience, it is still extremely interesting.

Another complaint made by those who work there is that of hearing voices coming from the main corridor (the "mall area") when nobody is actually in there. In fact, one employee has heard her own name called on several occasions from the deserted atrium, although the more frequent reports are of two voices holding an apparently hushed conversation.

Accepting this as a challenge, my colleagues and I spent the better part of an hour testing the acoustics in and around this area, heading downstairs to the parking garage and outside the building onto the surrounding streets, speaking normally and then yelling at the tops of our voices in an attempt to replicate the sound—all to no avail. So much for the crazy acoustics theory.

During the course of the investigation, when my crew was split into two teams working in different parts of the building, the sounds of hushed voices were indeed heard coming from somewhere out in the area of the main corridor. Whenever anybody went to investigate, the voices ceased. Motion-activated cameras were positioned covering the entire central atrium, backed

up by a digital voice recorder that was planted directly in the middle of the hallway and left running continuously.

During two separate EVP sessions, the sound of—you guessed it—hushed voices was heard coming from the central hallway. Nothing activated the remote cameras, but the same voices were picked up on the digital voice recorder. The conversation was a little too indistinct for us to make out the actual words themselves, or even the gist, but it does certainly sound like two voices talking in a meaningful way. On the second occasion, a city employee was posted to watch the central corridor. He saw—and, perhaps more importantly, heard—nothing at all, including any voices coming in from the street outside.

The council chambers complex has one significantly tragic event in its semi-recent past. During April 1981, a female employee who worked there was in the process of an acrimonious divorce and simultaneously dating one of her male co-workers. According to the female employee's testimony (as quoted in a series of articles written for the *Longmont Times-Call* by Jim Bishop in the summer of 1982), her estranged husband arrived at the council chambers one day and met with both her and her lover in a conference room inside the building. The husband insisted that she spend one last night with him, as a condition for his getting out of her life and leaving her alone forever. When the female employee refused this condition, she testified that her husband stated, "I knew when I came here today that there were two options. Either you would agree to what I asked, or I would be prepared to spend fifty years in Canon City." (This statement refers to the Colorado Territorial Correctional Facility.)

If the female employee's statement is correct, then the implication is very clear: her husband went to the council chambers with the express intention of murdering her and her lover. This is further backed up by the fact that he then stood up and removed a .357 Magnum revolver from inside his coat.

As the female employee bolted from the room and fled, the shooting started.

The husband would later claim that he had purchased the pistol in order to kill himself but, after putting the gun to his head on two separate occasions, could not bring himself to do so. When the .357 came into plain sight, the woman's lover and another male employee pounced on the estranged husband in an attempt to subdue him and secure the gun. At trial, he denied intent to murder, claiming, "I couldn't see nothing, and I just started shooting. I'm not pointing at nothing. I'm just trying to keep this guy off me."

Whatever the killer's motivations truly were on that day, the fact is that he shot two men in the financial department conference room of the

council chambers complex, and despite valiant efforts by Longmont EMTs and paramedics, both victims subsequently died in the emergency room at Longmont United Hospital—entirely understandable when something as powerful as a .357 Magnum was the murder weapon. As he fled the scene on foot (running out into the same central corridor from which the disembodied voices are heard), a Longmont police officer got the drop on him and took him into custody.

At the trial's conclusion, the estranged husband was convicted of two counts of criminally negligent homicide on a plea deal, which for two victims at that time carried a $10,000 fine and four years in jail.

Does this tragedy have any connection to the strange activity reported every so often inside the council chambers complex? It is difficult to say for sure. My team and I spent time conducting EVP sessions both in the conference room itself and the corridors outside. Although there were a number of bangs and thuds, these are easily attributable to the sounds of the building cooling down after what had been an unseasonably warm day. The atmosphere in the conference room was tranquil, and nothing anomalous came up on the digital voice recordings.

And yet, one thing of interest did occur. While I was sitting in the conference room with four colleagues, with both doors propped open and affording us a view into the empty hallways outside, the sound of something hitting the floor outside prompted us to take a look out into the corridor. The door sign that had been mounted next to the finance office was laying face-up on the carpet. This had fallen at the exact same moment that we were discussing the shooting.

Puzzled, I inspected the back of the sign and found it had been attached to the wall by two fairly sturdy adhesive strips. After photographing it in place, I stuck the sign firmly back onto the wall, and in what must have appeared to be truly bizarre, we launched into a series of vibration-generating activities in an attempt to dislodge it once more. A bunch of heavy people jumping up and down in unison, while one kicked the base of the wall and another thumped the back of it heavily with his fist, all failed to dislodge the sign once again. We were forced to manually tug it away from the wall, requiring quite a bit of effort.

Corralling the occupant of an adjacent office, I asked her if the sign had ever fallen down from its mounting place in the past. To the best of her knowledge, it had not.

FIRE IN THE SKY

FEDERAL AVIATION ADMINISTRATION BUILDING—2211 SEVENTEENTH AVENUE, LONGMONT

This state of the art air traffic control center, located on the westerly end of Seventeenth Avenue, is one of the last places that you might expect would be haunted. The FAA facility was built in 1962 on the site of a former Dickens family homestead, and according to some staff members, employees have reported seeing a shadowy figure roaming the corridors after dark. This shadowy figure is believed by some of the long-term employees to be the spirit of a former janitor who is said to have died on the premises. The ghost often gets the blame for objects seeming to move around by themselves and for employees being touched by some unseen hand.

The FAA building is only getting a brief mention in these pages because the claims of a haunting are primarily word of mouth and appear on a couple paranormal websites. But as we come to the conclusion of our journey through Longmont's haunted history, no discussion of the city's darker side would be complete without at least covering the events of November 1, 1955, in the night skies over Longmont. Although there are (to my knowledge) no ghosts involved, this well-documented story continues to haunt the city today.

At three minutes past seven o'clock on a bitterly cold and windy evening, United Airlines Flight 629 (a D6-B given the name "Mainliner Denver")

was blown out of the sky some eight miles over the northeastern fringe of Longmont. All forty-four souls aboard (one of them a baby) perished in the explosion and the subsequent crash, as the disintegrating aircraft parts came raining down over an area encompassing several sugar beet fields.

The tragic incident was witnessed by local farmers, who wasted no time in alerting the authorities. But the mid-air explosion was heard for miles around, and citizens flocked to the scene out of a morbid sense of curiosity. Fortunately, in addition to the anticipated emergency services response, artillerymen from the Longmont National Guard battery were soon deployed to the scene in order to offer assistance. Simply controlling the roads and turning away the rubberneckers was a major task, and the presence of armed troops helped to secure the scene.

A priest performed the nondenominational equivalent of the Last Rites upon each body as he came to it, moving from passenger to passenger. United Airlines sent a crash response team to the scene, bringing with them supplies to help contain and transport a significant number of corpses. The National Guard shipped the bodies to Greeley, storing them in a temporary morgue set up inside the armory there.

Such a large incident was inevitably going to attract the attention of the Federal Bureau of Investigation, and G-men descended on the scene rapidly, immediately fingerprinting the passengers' bodies and hunting for connections and a possible motive. It did not take long before the suspicious gaze of the federal agents fell upon a petty criminal named Jack Gilbert Graham, a young man with a history of forgery in his past, along with a more colorful arrest for "hauling whisky in violation of Texas laws."

Graham's mother, Daisie E. King, was one of the deceased passengers of Flight 629, and it turned out that before she left for Stapleton Airport on November 1, her son had given her a "gift" to take with her on the flight, wrapped in Christmas gift paper. When the agents dug deeper, they found that Graham had mailed himself a life insurance policy from the airport, taken out on his mother—and with himself as the named beneficiary. The policy was hidden away inside a locked chest in his home. Material for manufacturing explosives was also found. Storekeepers stated that they had sold Graham other quantities of suspicious material. The more that the FBI agents questioned Jack Graham and his relatives about his means and motive for murder, the more that his story deviated from that of everybody else.

The FBI had no hesitation in charging him with the crime of first-degree murder.

Despite his employment of the insanity defense, Graham was found to be sane by a quartet of psychiatrists and was able to stand trial as a competent defendant. It took just over an hour for the jury to find him guilty.

Jack Gilbert Graham died strapped into the chair of the gas chamber at Canon City Penitentiary, killed by a lethal dose of cyanide poisoning. It is more than a little ironic to consider the fact that, according to the physician in attendance at the execution who later certified him dead, Graham took eleven minutes to asphyxiate—precisely the same amount of time that the aircraft full of his victims had been airborne before he murdered them all.

Readers who want to learn more about this tragedy are encouraged to seek out Andrew J. Field's superlative study, *Mainliner Denver: The Bombing of Flight 629*. Field makes this haunting observation toward the end of his book:

> *The tragedy left an indelible impression on the land northeast of Longmont. Literally. The following spring, a farmer who planted alfalfa in a field where several of the victims had landed noticed that the seed would not take hold in the areas of earth that had been compressed by the falling bodies. The phenomenon caused the crop to grow in eerie outlines of the deceased.*
>
> *For many years thereafter, cows that grazed in this area would occasionally die for no apparent reason. Postmortem examinations of the carcasses revealed the cause: intestinal blockages resulting from consumption of small pieces of plane wreckage that had risen to the top of the soil.*

Long before aviation security became a serious and widespread concern, the people of Longmont were given a tragic lesson regarding the horrific loss of life that could be inflicted by one callous individual, with an airplane as his target.

REFERENCES

INTERNET SOURCES

Ancestry.com. "Biography of Morse Coffin, 1836–1913." http://freepages.genealogy.rootsweb.ancestry.com/~mycoffinroots/Coffin_Morse_bio.html.

Bokan, Sharon. "Sandstone Ranch." Colorado Info. http://www.coloradoinfo.com/longmont/sandstoneranch.

Cheese Importers. "Who We Are." http://www.cheeseimporters.com/whoweare.html.

City of Longmont, Colorado. "Callahan House." http://longmontcolorado.gov/departments/departments-a-d/community-services-department/callahan-house.

———. "Callahan House History." http://longmontcolorado.gov/departments/departments-a-d/community-services-department/callahan-house/history.

———. "Fire History: The Longmont Fire Department Story." http://www.longmontcolorado.gov/departments/departments-n-z/public-safety-department/public-safety-chief/history-of-department/fire-history.

———. "Imperial Hotel." http://longmontcolorado.gov/departments/departments-n-z/planning-and-development-services/historic-preservation/designated-landmarks/imperial-hotel.

Curry, Mary Elizabeth. "Penney, J.C." American National Biography Online. http://www.anb.org/articles/10/10-01295.html.

Dickens Tavern. "Ghost Stories." http://www.dickenstavern.com/ghost-stories/.

———. "Our History." http://www.dickenstavern.com/our-history.html.

Elite Barber Shop. "140 Years of Tradition." http://elitebarbershop.net/elitebarbershop/?page_id=9.

Federal Bureau of Investigation. "Famous Cases and Criminals: Jack Gilbert Graham." http://www.fbi.gov/about-us/history/famous-cases/jack-gilbert-graham.

Find-A-Grave. "Morse Houghtaling Coffin." http://www.findagrave.com/cgi-bin/fg.cgi?page=gr&GSvcid=236241&GRid=16267363&

Fyke, Gary. "Chillicothe, Tom Callahan, and J.C. Penney." Peoria Magazines. http://www.peoriamagazines.com/ibi/2011/jan/chillicothe-tom-callahan-and-jc-penney.

Gladych, Paula Aven. "Students Search for Signs of Specter." *Vail (CO) Daily*, November 7, 2005. http://www.vaildaily.com/article/20051107/NEWS/111070016.

Haunted Colorado. "The Historic and Haunted Hansen Building." http://www.hauntedcolorado.net/Longmont.html.

Lockdown Paranormal. "Callahan House." http://www.lockdownparanormal.com/callahan-house.html.

Longmont Theatre Company. "About Us." http://longmonttheatre.org/about-us/.

Schow, Peter. "Longmont Then and Now #15: Hansen Building (1905–)." December 11, 2010. http://longmontian.blogspot.com/2010/12/longmont-then-and-now-15-hansen.html.

———. "Longmont, Then and Now #5: The Imperial Hotel and Main Street, 1909." November 22, 2007. http://longmontian.blogspot.com/2007/11/longmont-then-and-now-5-imperial-hotel.html.

Sherwood, Glen. "WWII Prisoner of War Barracks." http://www.historiclongmont.org/725eleventh.html.

St. Vrain Historical Society. "Old St. Stephen's Church." http://www.stvrainhistory.org/Old_St_Stephens.html

St. Vrain Valley School District. "The Myths Surrounding the Ghosts of Mr. Dickens." https://sites.google.com/a/svvsd.org/williams-dickens/home/sub-topic.

Turner, Carol. "The Mysterious Death of William H. Dickens." https://caturner.wordpress.com/2011/10/19/mysterious-death-of-william-h-dickens/.

Utterback, Chris. "Longmont's Cheese Importers Find New Life in Old Building." http://www.westword.com/restaurants/longmont-s-cheese-importers-finds-new-life-in-old-building-5724855.

Wikipedia. "J.C. Penney." http://en.wikipedia.org/wiki/James_Cash_Penney.

———. "The Sand Creek Massacre." http://en.wikipedia.org/wiki/Sand_Creek_massacre.

Books/Periodicals/Articles

Bryen, Whitney. "Longmont Honors Family's Vision of Callahan House After 75 Years." *Longmont (CO) Times-Call*, August 31, 2013.

Field, Andrew. *Mainliner Denver: The Bombing of Flight 629*. Boulder, CO: Johnson Books, 2005.

Hansford, Nancy. *Northern Colorado Ghost Stories*. Fort Collins, CO: Indian Hills Book Works, 2005.

Kindlespire, Tony. "Cheese Importers Could Move to Old Longmont Power Plant." *Longmont (CO) Times-Call*, February 10, 2012.

Reed, Matt. *Longmont (CO) Times-Call*. Fragment of a 1985 article with unknown title.

Wommack, Linda. *From the Grave: A Roadside Guide to Colorado's Pioneer Cemeteries*. Caldwell, ID: Caxton Press, 1998.

ABOUT THE AUTHOR

Born and raised in Leicestershire, England, Richard Estep relocated to the United States in 1999 and brought his passion for ghost hunting along with him. As co-founder and director of the Boulder County Paranormal Research Society, he continues to investigate claims of paranormal activity on both sides of the Atlantic. Richard makes his living as a paramedic and clinical educator; in his spare time, he serves as a volunteer firefighter, is the designated human for a small menagerie of cats and dogs and builds an unhealthy amount of Lego.